Remembering
Oklahoma

Larry Johnson

TURNER
PUBLISHING COMPANY

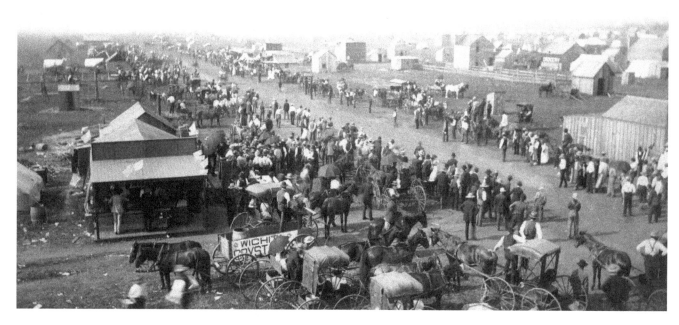

On July 4, 1889, all of Guthrie lined up to celebrate the nation's 113th birthday and to show the town's appreciation for a special visitor: Representative Bishop Walden Perkins. The Kansas congressman was called by some the "Father of Oklahoma" because of his successful attachment of the Oklahoma clause, which called for opening portions of Indian Territory to white settlement, to the Indian Appropriations bill.

Remembering

Oklahoma

Turner Publishing Company
4507 Charlotte Avenue • Suite 100
Nashville, Tennessee 37209
(615) 255-2665

Remembering Oklahoma

www.turnerbookstore.com

Library of Congress Control Number: 2010932278

ISBN: 978-1-59652-705-8
ISBN-13: 978-1-68336-863-2 (pbk)

Printed in the United States of America

CONTENTS

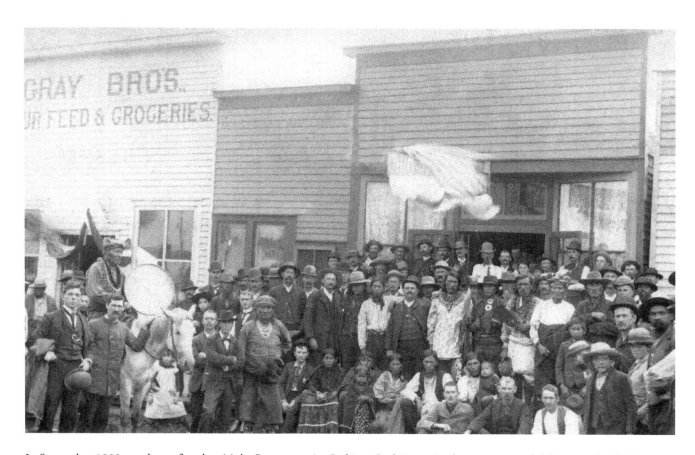

In September 1889, not long after the visit by Representative Perkins, Guthrie received a congressional delegation that had traveled west to inspect the conditions in Oklahoma. Here, Iowa Indians pose in front of Nowlan's Restaurant. They had come from their nearby reservation seeking the approval of the congressmen to unite with the Otoe tribe.

ACKNOWLEDGMENTS

This volume, *Remembering Oklahoma,* is the result of the cooperation and efforts of many individuals, organizations, and corporations. It is with great thanks that we acknowledge the valuable contribution of the following for their generous support:

Library of Congress
Oklahoma Historical Society

The author would like to thank Pamela and Margaret Hell for their valuable assistance in selecting photographs for this volume.

Madeleine Claire, Victoria, and Jandy provided wonderful suggestions and support in the writing of the text.

————————

With the exception of cropping images where needed and touching up imperfections that have accrued over time, no other changes have been made to the photographs in this volume. The caliber and clarity of many photographs are limited to the technology of the day and the ability of the photographer at the time they were made.

PREFACE

In many families, the first few years of the first-born child are fully documented on film. From the first day, the photo albums begin to pile up; but as years go by, the albums get thinner, and before long the annual school photo is the only reliable photographic record of the person's childhood. So it has been with several Oklahoma towns and cities. Because of their instant birth, the first days of many Oklahoma towns are remarkably well recorded; but from later years, mostly what remain are staid real-estate photographs and views of commercial districts. As one moves into the 1950s and 1960s, the photographs available from archives begin to dwindle, dissipating further in the 1970s.

Still, Oklahoma has an excellent photographic record of life in what was then Indian Territory, before the arrival of the town builders. Photography in the late nineteenth century had become portable, affordable, and popular. By that time, the Five Civilized Tribes (Cherokee, Chickasaw, Choctaw, Muscogee [Creek], and Seminole) had been in eastern and southern Indian Territory for over 50 years. Photographs of that part of the state in that era depict the numerous missionary boarding schools in the region as well as the large homes built by the more fortunate members and leaders of the tribes.

In the west, the scene was quite different. There, images of the movable dwellings of nomadic plains tribes are contrasted against the primitive dwellings of white settlers. Photographers like Will Soule and Edward Curtis were moved by the belief that Indian Territory represented the last opportunity to capture indigenous cultures in their natural states. Although these men may not have been thoroughly knowledgeable about the cultures, they were generally earnest in their respect for the tribes, and a great debt is owed them for preserving images of these people and their lives. Likewise, lensmen such as William S. Prettyman and Andrew Forbes are remembered for their work with some of the last real working cowboys and drovers as they worked the ranchlands of the west and the panhandle.

Remembering Oklahoma is not an illustrated history of Oklahoma, nor is it an attempt at a visual chronology of the state. Readers seeking photographs of famous people and landmark buildings (though there are a few) may be disappointed. Rather, the selection of photographs here tells the story of this diverse group of people called Oklahomans as witnessed in their faces, the homes they cherished, and the streets they lived in.

Just as viewing a succession of those school photos reveals the periods of beauty and awkwardness, innocence and maturity, hardship and joy in a child's life, the reader of this book will see the tragedy of Indian removal, the exuberance of land runs, the shame of segregation, the anguish of the Great Depression, and the optimism for the future. In between are glimpses of how we used to live, work, and play in the 46th state of the Union.

— *Larry Johnson*

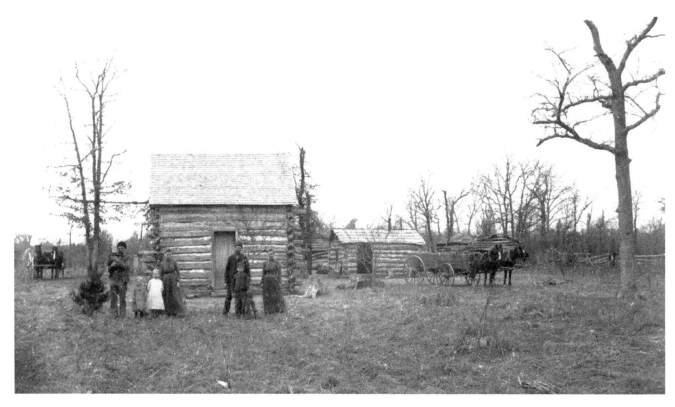

The Finley Bowen family stands outside their homestead northeast of Coyle. This photo was likely taken in the aftermath of a tornado outbreak across Kingfisher and Logan counties on May 2, 1892. Damage looks slight here, but three died in Kingfisher and several buildings were destroyed.

WAY DOWN IN THE INDIAN NATION

(1870s–1900)

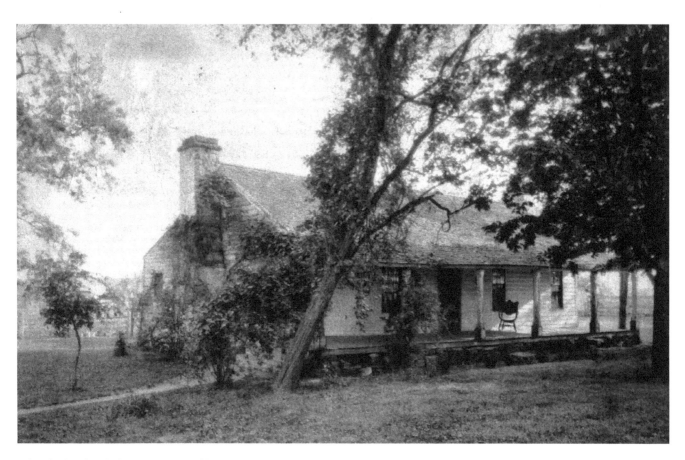

After the battle of Claremore Mound between the Osage and newly arrived Cherokee in 1817, the Army established a presence in the Three Forks area to keep the peace. The building seen here was erected in 1818 (though photographed much later) and housed officers until Fort Gibson was built nearby in 1824.

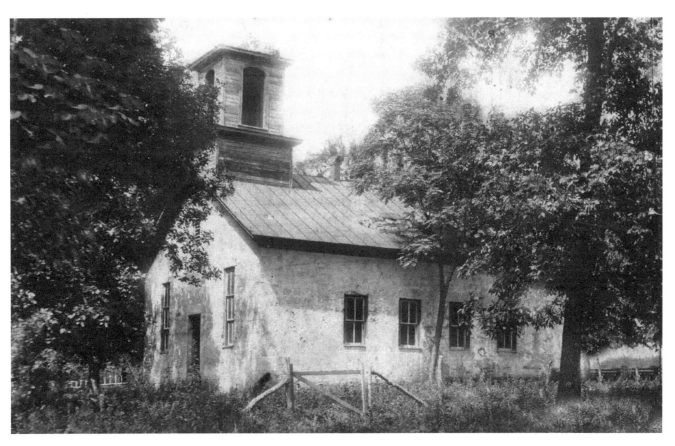

The Presbyterian missionary Alfred Wright had worked among the Choctaw in Mississippi beginning in the 1820s and resumed his work in Indian Territory after the removal. In 1846, parishioners from his Wheelock mission near Idabel built this stone church—it stands today as the oldest church in Oklahoma.

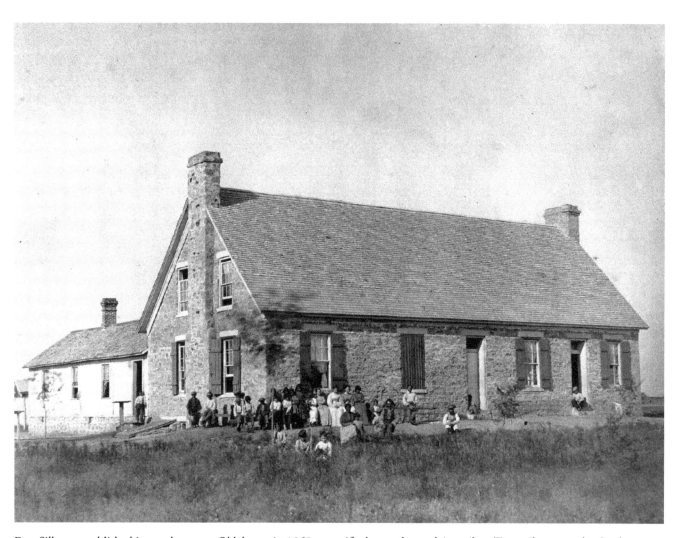

Fort Sill was established in southwestern Oklahoma in 1869 to pacify the southern plains tribes. Two miles away, the Quakers operated the Kiowa-Comanche Agency, where they constructed this school from native stone in 1871.

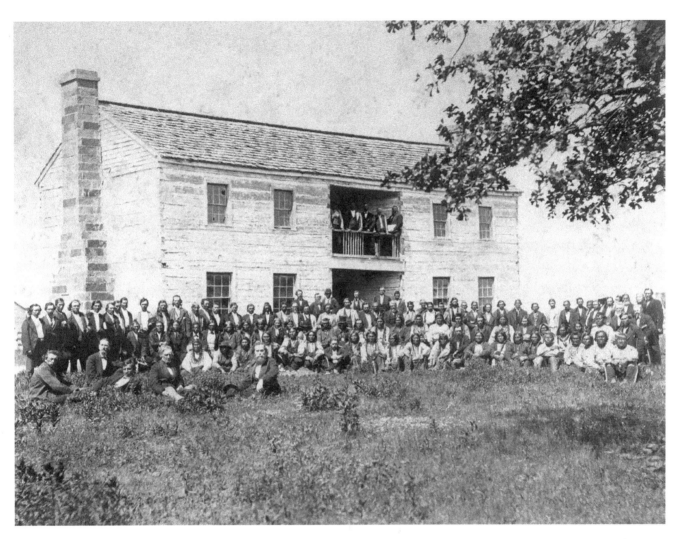

In 1875, representatives from most of the tribes in Indian Territory met at the Grand Council at the Creek Nation Courthouse in Okmulgee. Discussions centered on the possibility of an all-Indian state joining the Union, and members drafted a constitution that called for a territorial governor, U.S. courts, and a delegate to Congress.

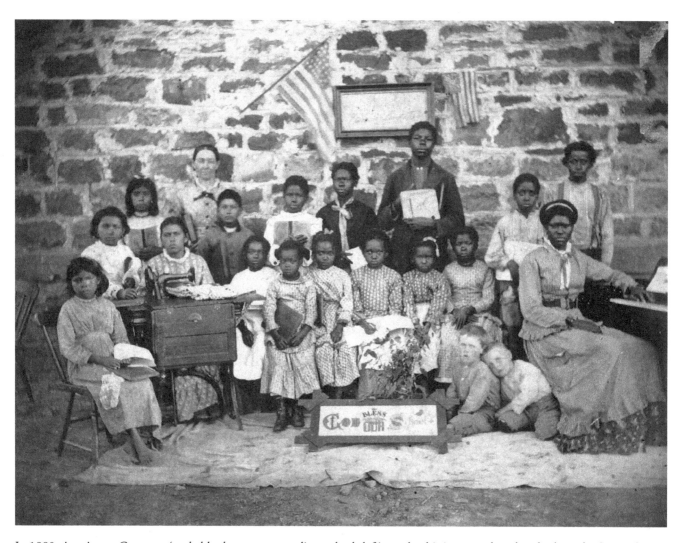

In 1880, Antoinette Constant (probably the woman standing at back-left) taught this integrated student body at the Seminole school in Wewoka. But after she defended a woman that the tribe had accused of witchcraft in a Salem-style trial, Seminole chief John Chupco declared, "Get another *ma-hi-va* (teacher)," and she was fired on the spot and not allowed to teach in Seminole country again.

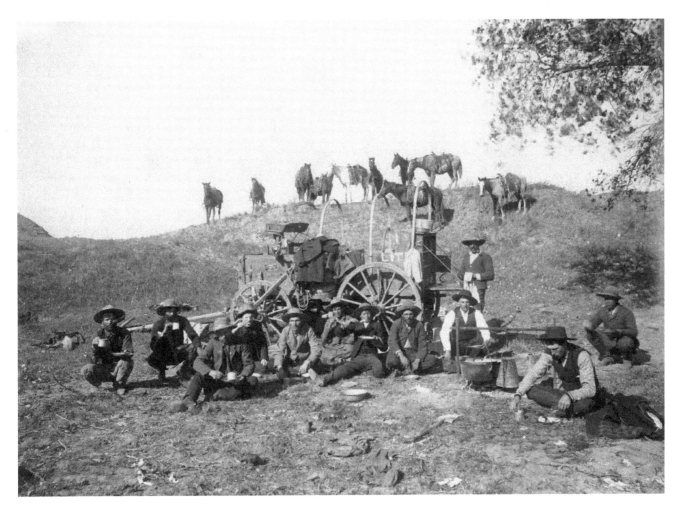

In 1887, noted photographer William S. Prettyman roamed Indian Territory living the range life of the cowboy and capturing on film the last bit of unclaimed prairie in America. Here he depicts a cowboy dinner on Ross Stratton's Turkey Creek ranch near the present site of Enid. Stratton is third from the left.

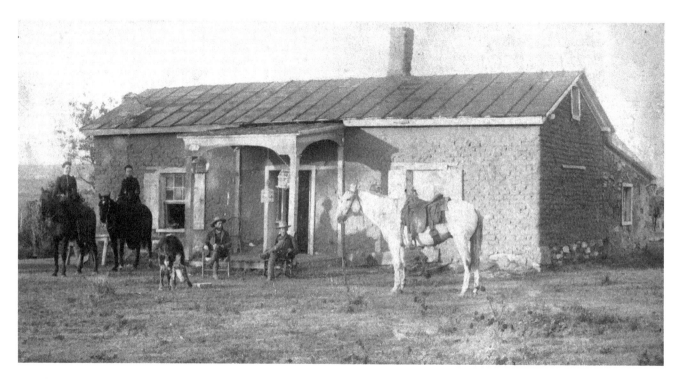

Not then attached to any state, No-Man's Land comprised miles of lucrative rangeland for cattle. Some ranchers did quite well, as seen in this photo from about 1889. Though it was a lawless land, one early rancher recalled, "The honest-to-God truth is that more people died from ennui and nostalgia than perished in outlaw combats."

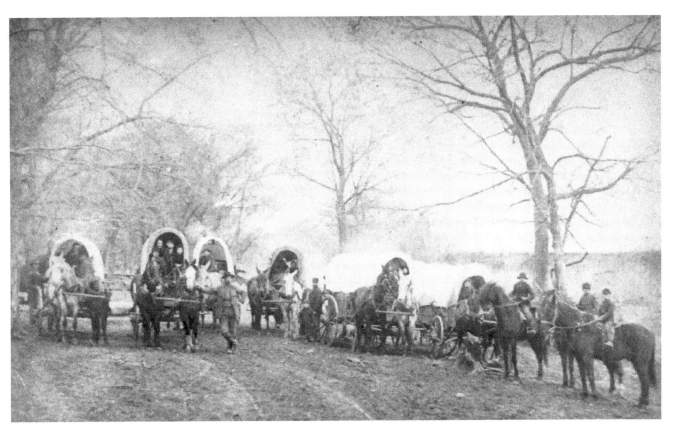

A family crosses into the Unassigned Lands at their opening, April 22, 1889. One observer in Purcell wrote that in the predawn hours of that day he saw "the ghostly forms of prairie schooners moving toward the ford a mile north of town."

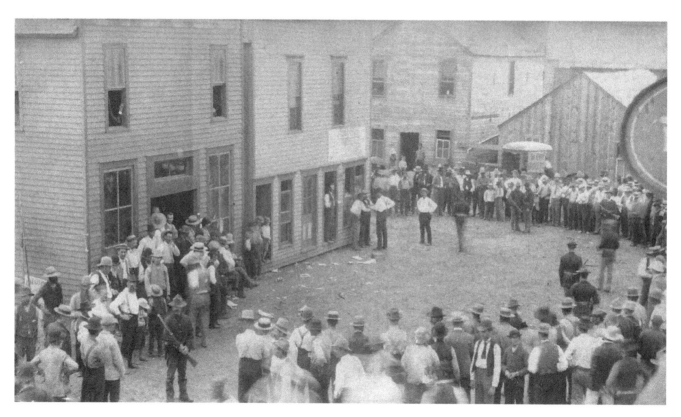

Crowds gather in Purcell in the days before the land opening of 1889. Purcell stood just a mile south of the Canadian River on the Santa Fe Railroad. On April 23 a newspaperman reported, "Yesterday it was a metropolis, to-nite it is a hamlet . . . the scenes of this hegira will never be erased from the memory of those who witnessed them."

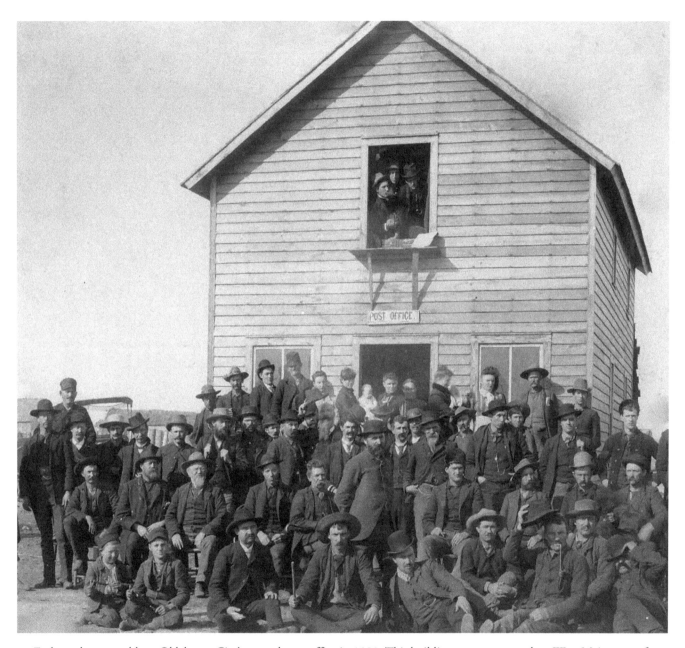

Early settlers assemble at Oklahoma City's second post office in 1889. This building was constructed on West Main across from the Santa Fe tracks about two weeks after the opening. At the time, it was the sturdiest building in town and served as a meeting place for churches, Sunday schools, the YMCA, and even Indian councils.

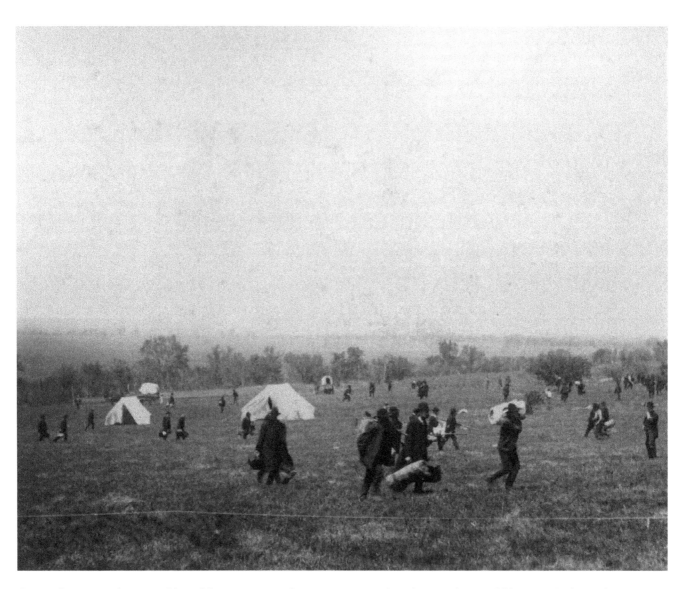

On April 22, 1889, homestead hopefuls stream across the open prairie to claim lots in what would become Guthrie. About 10,000 people settled in the new town by sundown on the first day of the land opening.

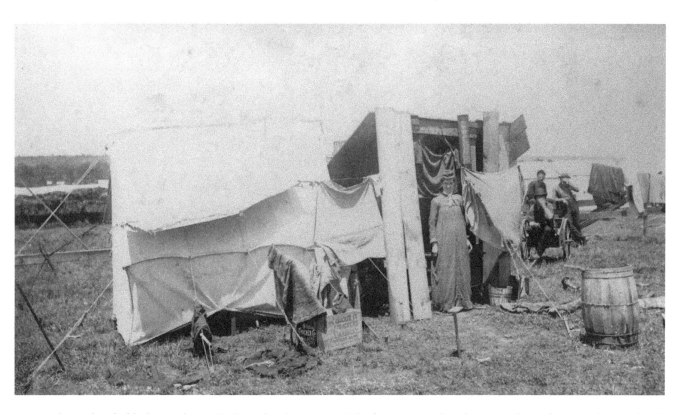

An early resident holds down a lot in Guthrie after the opening. The facts surrounding this particular settler are unknown, but it was common in the early days for women and children to occupy a claim while men made the arduous trip to the land office to file, or went in search of work to provide necessities for the family.

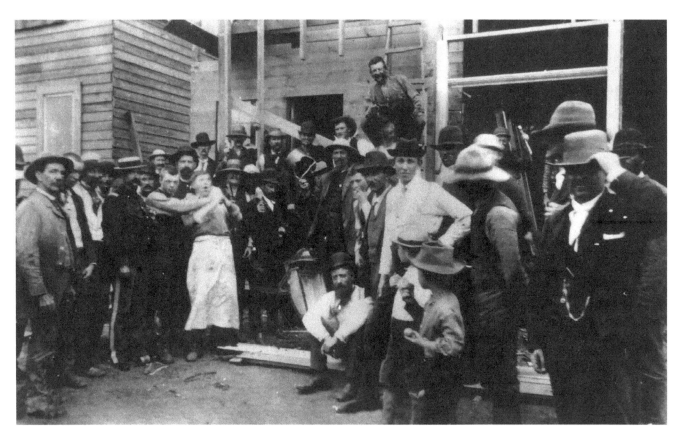

This scene in Guthrie just after the destruction of a supply of liquor by federal officials was photographed in May 1889. Contrary to public opinion, the government considered the newly opened land in Oklahoma still a part of Indian Territory, where liquor was forbidden. When Oklahoma Territory was formed in 1890, prohibition was removed.

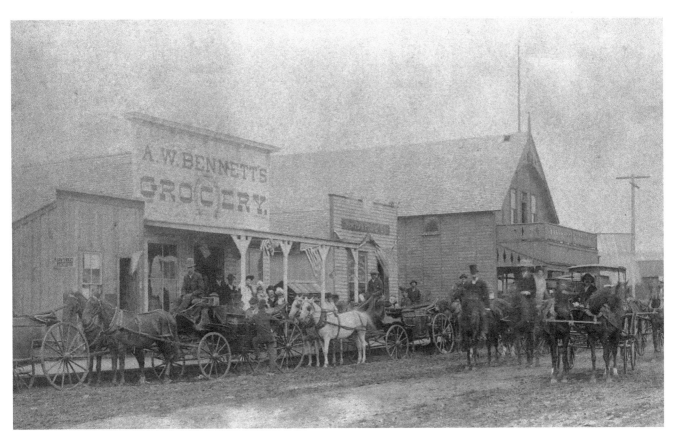

St. Louis and Kansas City newspapers reported that Guthrie provided a royal reception to six visiting congressmen in September 1889. These carriages were assembled to carry the visitors in a parade down Oklahoma Avenue—a parade that included about 3,000 of the town's 10,000 inhabitants.

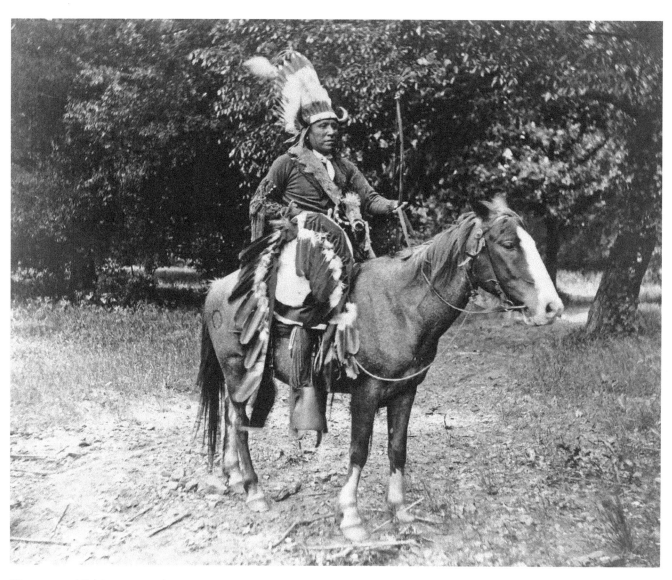

Kiowa scout Elk Tongue was photographed in full war regalia, ca. 1891. Recruited at Fort Sill in 1875, the Kiowa Scouts were later incorporated into the famed 7th Cavalry as Troop L. The scouts performed admirably and were fiercely loyal to their commander, Lieutenant Hugh L. Scott, who communicated with them in their own language.

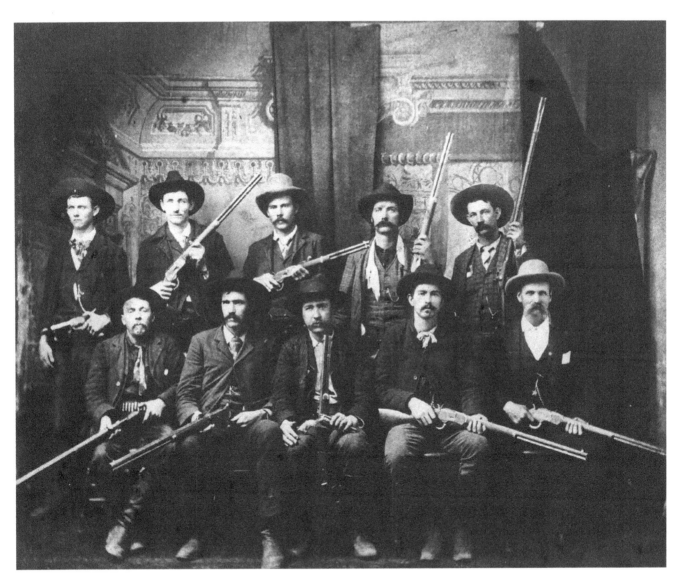

One of the more enduring controversies in Oklahoma history is that of Cherokee outlaw Ned Christie. Falsely accused of the murder of a marshal in Tahlequah, Christie went on the lam and evaded capture for five years until Marshal Paden Tolbert's posse, seen here, caught up with him in 1892, and Christie was killed in the ensuing confrontation. He was later exonerated.

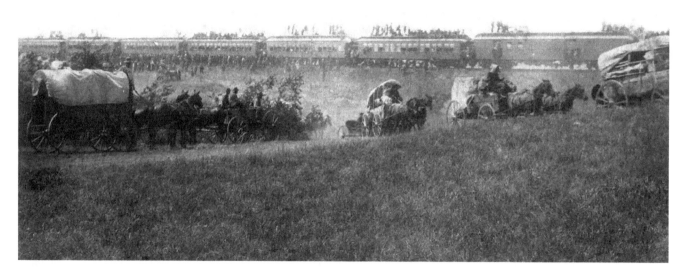

Somewhat juxtaposed to the famous "horse-race photo" of the opening of the Cherokee outlet in 1893, this photo shows some of the 25,000 people who began the land run from the line north of Orlando. Fast riders usually ran ahead in order to drive in their stakes while their families followed in the slower prairie schooners.

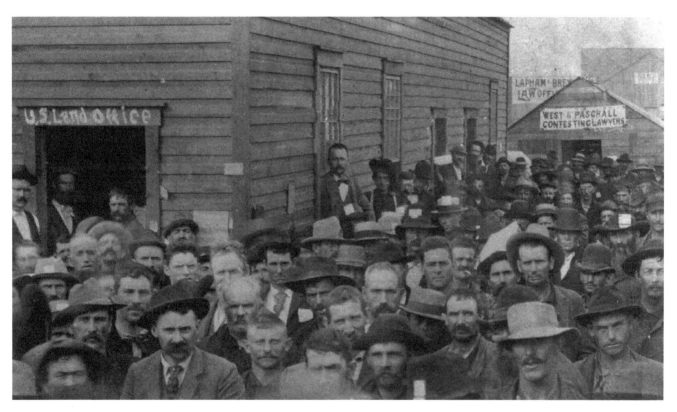

There were no smiles on the faces of this crowd waiting to file their claims at the Perry land office in September 1893. More than 100,000 people swelled the ranks of the new town, waiting in lines over a mile long. Some in line died, or fainted from sunstroke and lack of water as officials were unprepared for the sheer numbers of people making the land run.

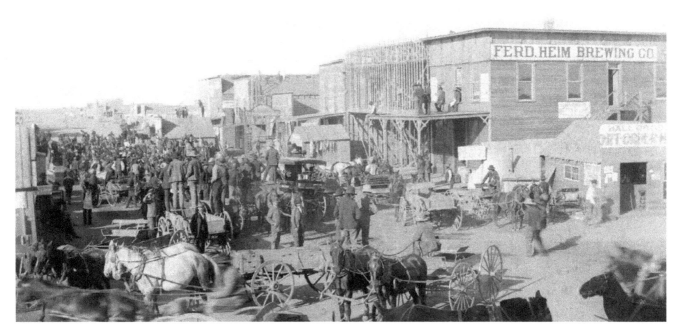

This is the view north from the corner of Sixth and C streets in Perry in October 1893. Perry quickly became the chief town in the newly opened Cherokee Outlet largely because its town lots were laid out by about 200 well-prepared sooners 15 minutes before the first settlers arrived from the starting line.

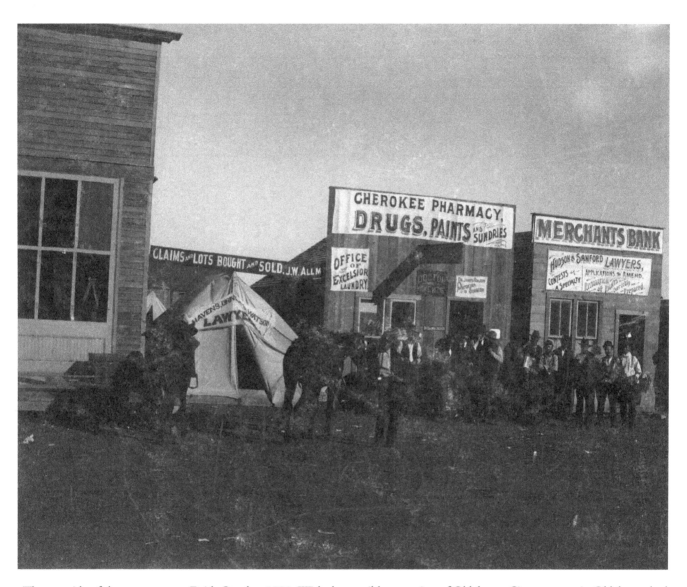

The east side of the town square, Enid, October 1893. With the possible exception of Oklahoma City, no town in Oklahoma had a more violent beginning than Enid, where railroad men, government officials, and settlers squared off in a battle over the location of the town site. By statehood, though, Enid was the fourth-largest city in Oklahoma.

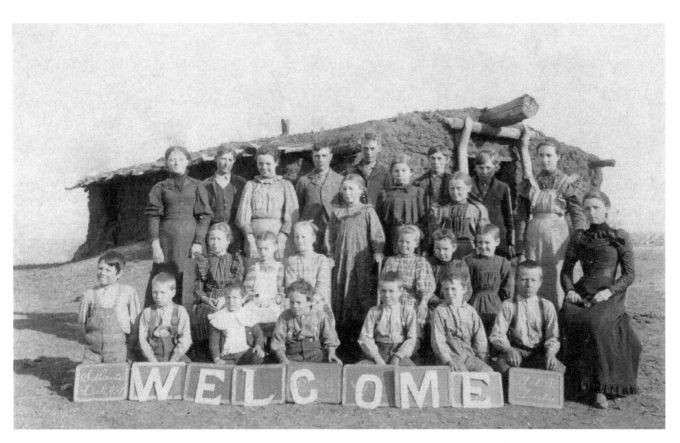

Blaine County was formed after the opening of the Cheyenne-Arapaho lands in 1892 and, as in most other areas on the treeless plain, sod structures were among the first erected in the county. The sod building seen here in 1893 was the Blaine County schoolhouse.

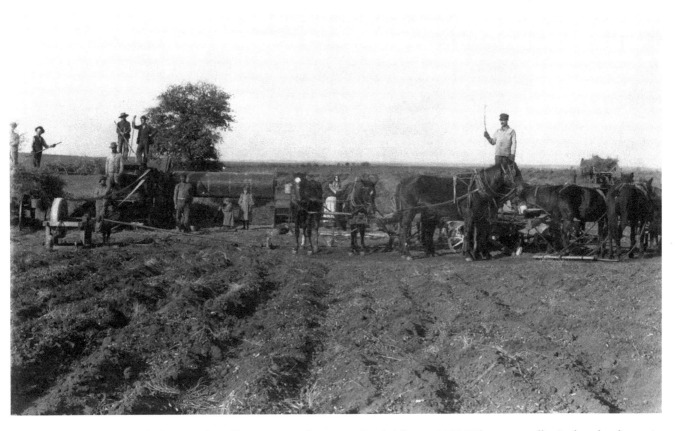

Processing threshed wheat on the Jefferson Bowen farm near Goodnight, ca. 1895. Wheat was well suited to the climate in northern and western Oklahoma, largely because it required little moisture.

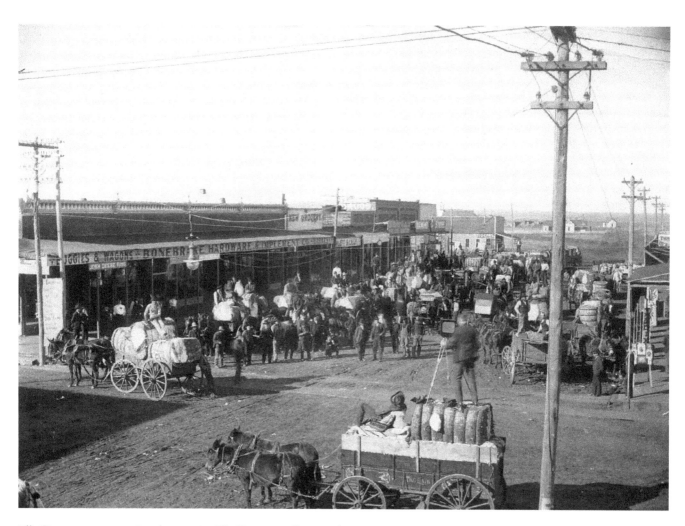

Elk City on cotton auction day, 1890s. Elk City was well situated as a major center for Oklahoma's cotton belt. By statehood, the town could boast two major rail connections, four cotton gins, and a cotton-oil mill.

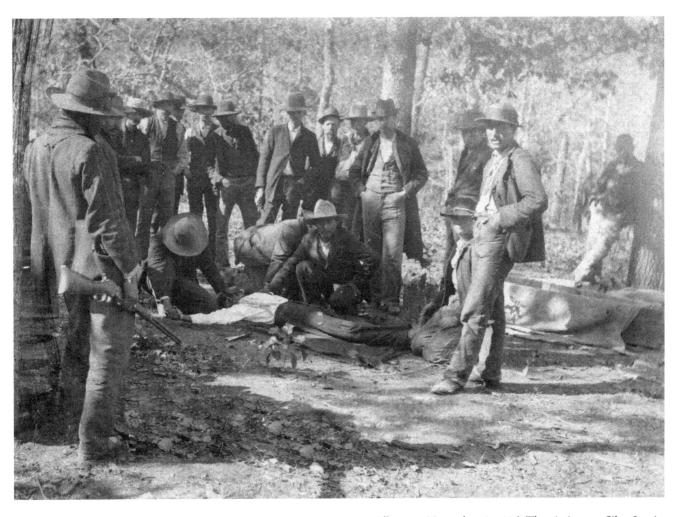

This photo was taken at the scene of the last Choctaw execution, at Wilburton, November 5, 1894. The victim was Silan Lewis, who was convicted of a political murder by the tribe and turned himself in as was tribal custom. Lewis was shot through the chest at close range and then smothered as the mournful wail of a woman arose from the creek bank.

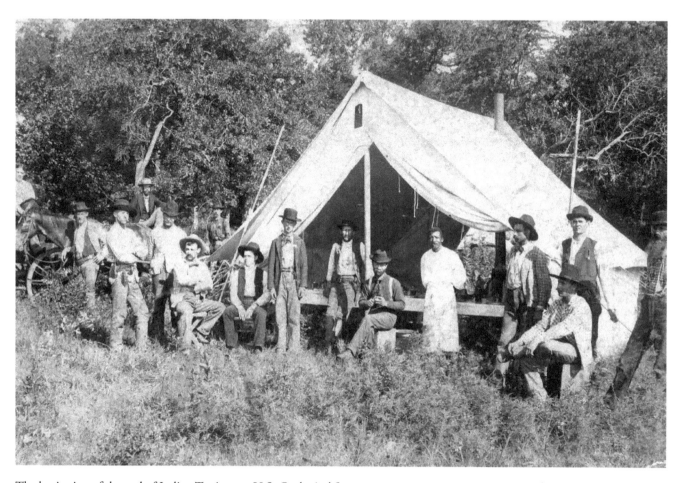

The beginning of the end of Indian Territory: a U.S. Geological Survey crew poses in camp, May 1895. The crew was responsible for surveying tribal land and dividing it into quarter-sections. These would then become allotments assigned to individual tribe members by the Dawes Commission.

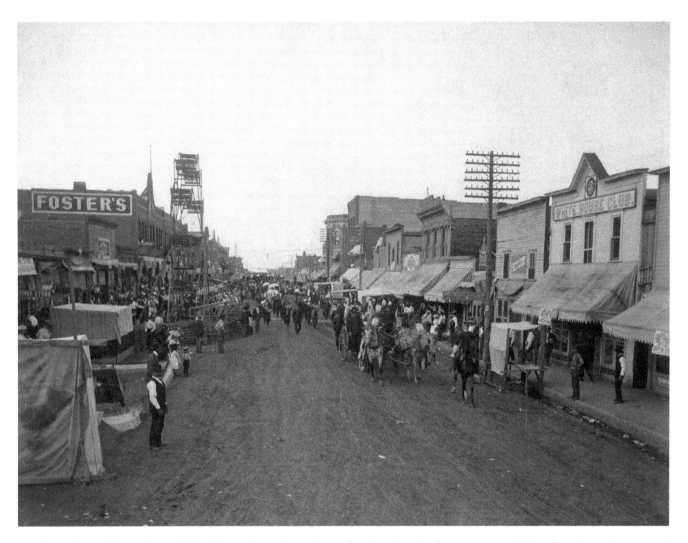

Street fair in Blackwell, ca. 1895. Blackwell was born during the Cherokee Outlet opening in 1893 and consistently prospered after the arrival of two major railroads and the discovery of oil and gas in the area.

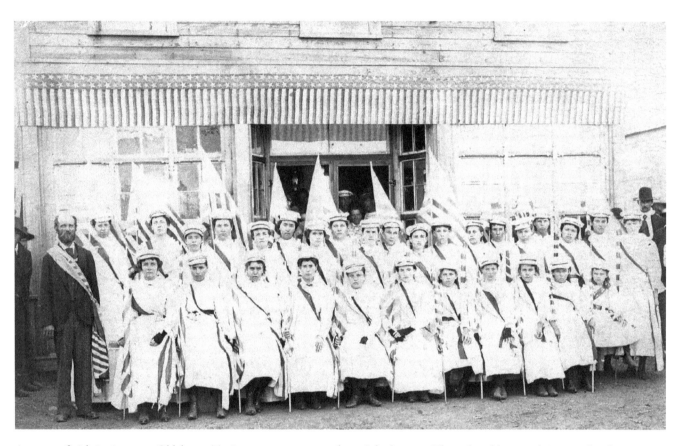

A group of girls in Augusta, Oklahoma Territory, prepare to march on July 4, 1898. The railroad bypassed Augusta by about a mile, and gradually the town drifted over to nearby Carmen. Augusta was the former home of Susanna Salter, who had been America's first female mayor, serving in Argonia, Kansas, prior to her arrival in Augusta.

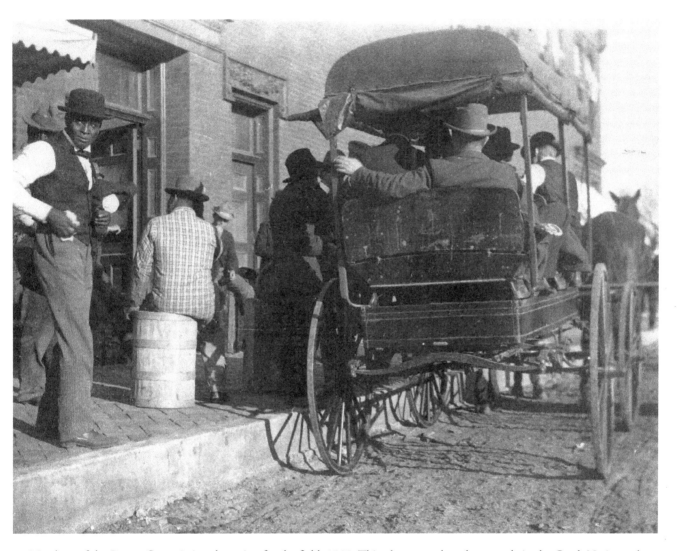

Members of the Dawes Commission departing for the field, 1899. This photo may have been made in the Creek Nation, where many freedmen had not been enrolled as tribe members due to confusion over their citizenship status. The commission made an effort to enroll as many freedmen as possible.

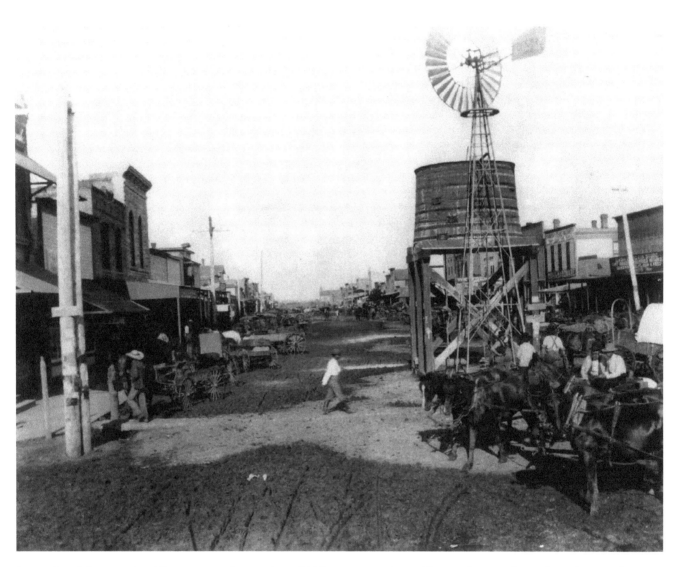

Ponca City, July 13, 1899. Like so many other northern Oklahoma towns, Ponca City was born on September 16, 1893, during the opening of the Cherokee Outlet, but the sleepy scene shown here would soon be miraculously transformed by the arrival of Marland Oil in 1911 and the opulence of the Roaring Twenties.

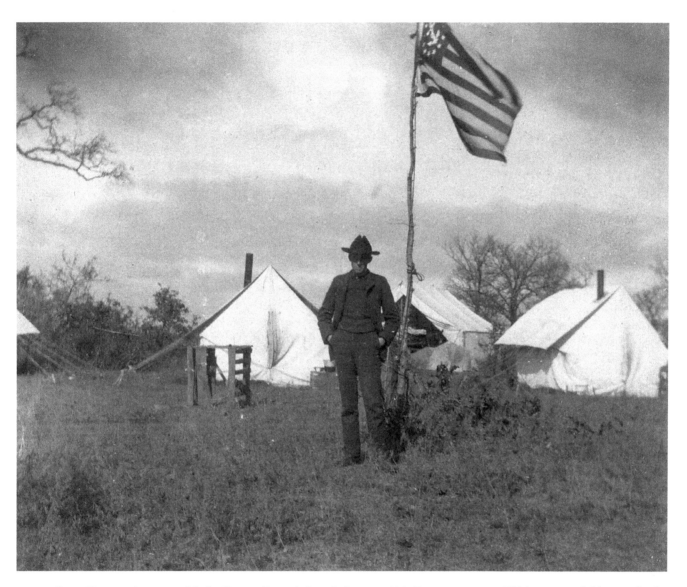

Grant Foreman in camp with the Dawes Commission, Ardmore, 1899. Foreman came to Oklahoma as a field agent for the commission but soon became a favorite son of his adopted hometown of Muskogee. In later years, he wrote tirelessly about Oklahoma history.

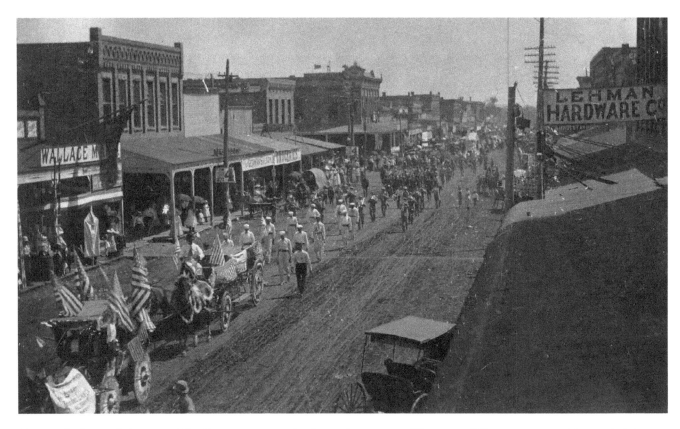

The parade during dedication of the Shawnee waterworks, September 1, 1899. The town of Shawnee arose amid several of the smaller tribes relocated to Indian Territory after the Civil War, but after its connection to Oklahoma City via the Choctaw, Oklahoma and Gulf Railroad, the town began to prosper and at times rival the future state capital.

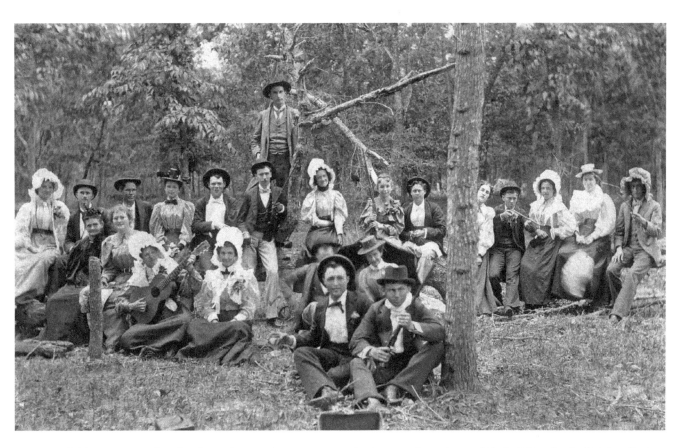

A youthful group, armed with rifles and musical instruments, take time out for a photo while frolicking in the Sulphur Springs resort area, ca. 1900.

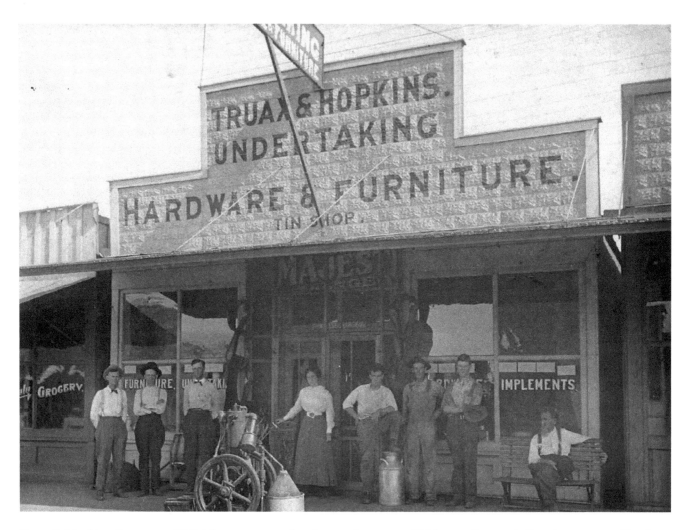

Truax & Hopkins, Beaver, ca. 1900. The remoteness of settlements in western Oklahoma often made Renaissance men of local merchants, as illustrated by this photo of the town's main street.

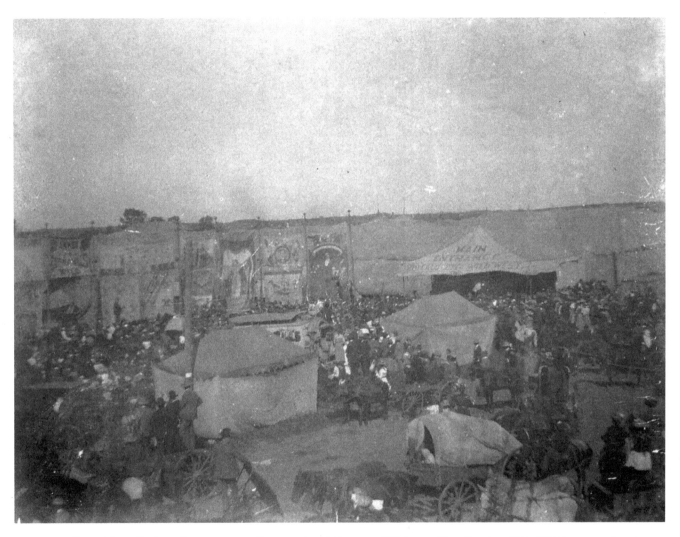

Buffalo Bill's Wild West Show encamped at Grand and Hudson, Oklahoma City, October 1900. While on a national tour, Colonel William "Buffalo Bill" Cody enjoyed a particularly friendly stop in Oklahoma City, where he had the chance to reunite with several other former Army scouts then living there.

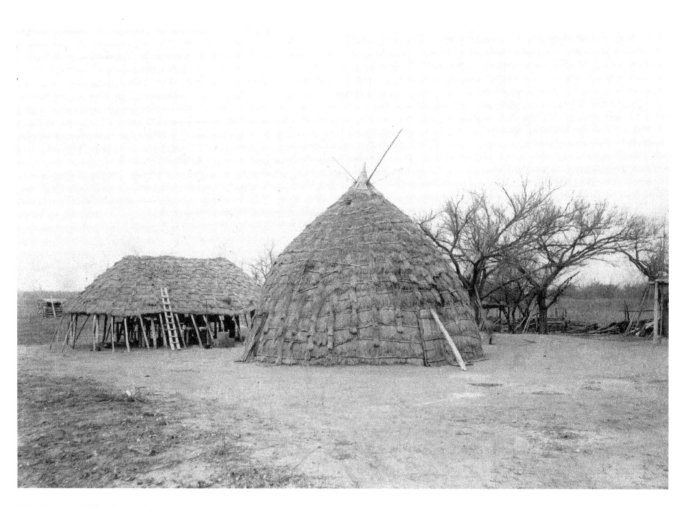

The home of Chief Tawakoni Jim is seen here near Anadarko in 1901. These wood-framed, thatched homes were typical of the Wichita and related tribes. The Wichita, although they lived among the equestrian tribes of the southern plains, practiced agriculture and were noted traders among the Spanish and French.

Territory Folks Should Stick Together

(1901–1929)

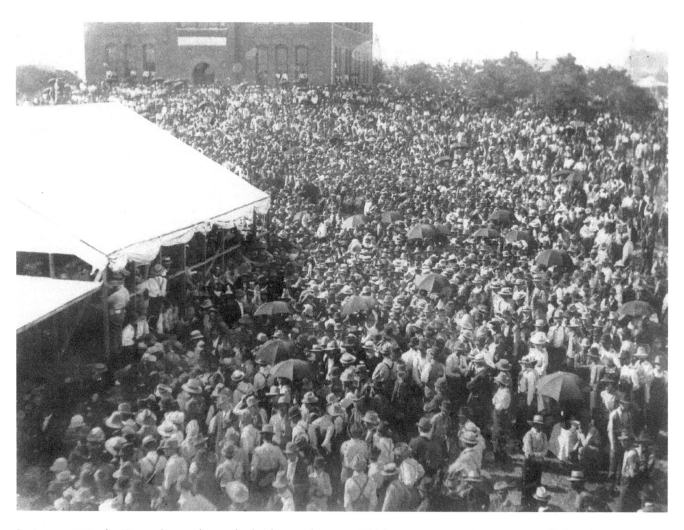

In August 1901, the Kiowa-Comanche surplus land in southwestern Oklahoma was opened to settlement. Rather than promote a chaotic land run, federal officials decided a lottery would be more orderly, so they required all home seekers to register for a chance at the 13,000 parcels of land. Over 160,000 showed up here in El Reno.

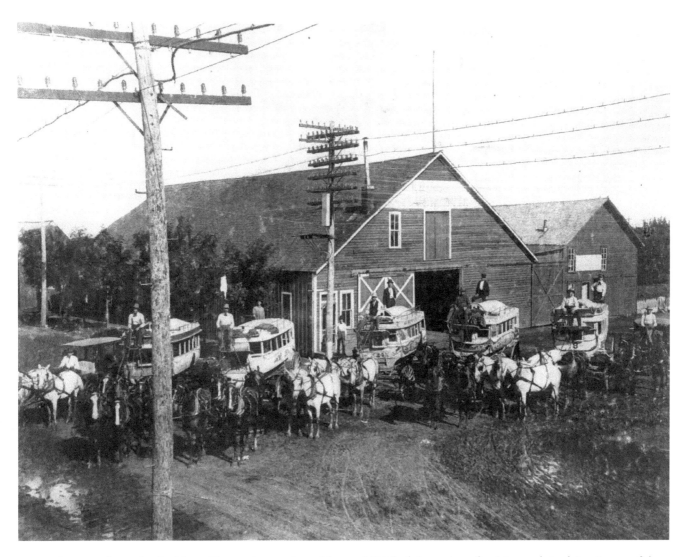

Lottery winners in the Kiowa-Comanche opening of August 1901 had the option of arriving at their claims in one of these chartered buses, seen in El Reno.

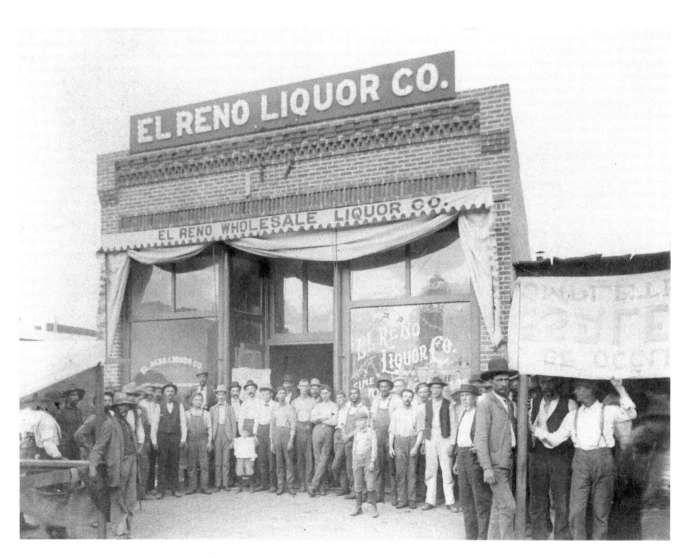

Distributors in El Reno were prepared to ply the newly wet Kiowa-Comanche lands with liquor after the opening in August 1901. Liquor sales were banned for 60 days until licenses could be issued, but the real money was made in selling water: it was going for 10¢ a vial while beer sold for 25¢ a quart.

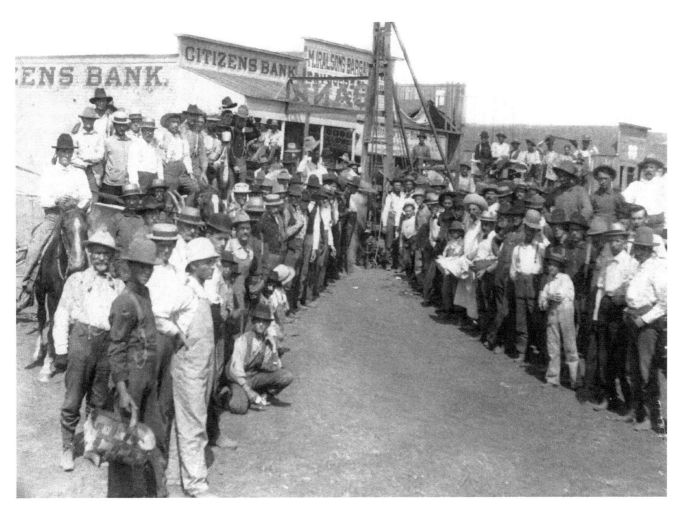

Just weeks after the new town of Lawton was established in 1901, dozens of oil companies formed to snatch up all available mineral rights. Here, a well appears in the middle of the business district. It is unknown whether this was a producing well.

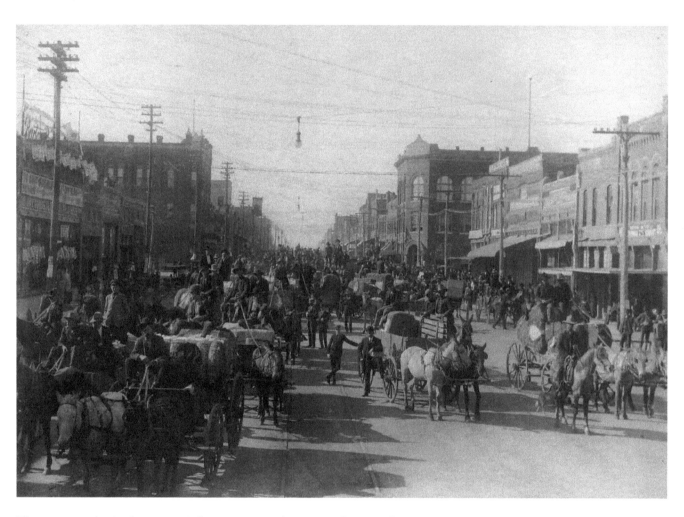

The cotton market in downtown Ardmore, 1902. Ardmore grew from a railhead for shipping cattle and cotton to a market center for the state's cotton production. One of four cotton compresses in the state was located in Ardmore, and thousands of bales of cotton made their way to U.S. and European mills from the booming town.

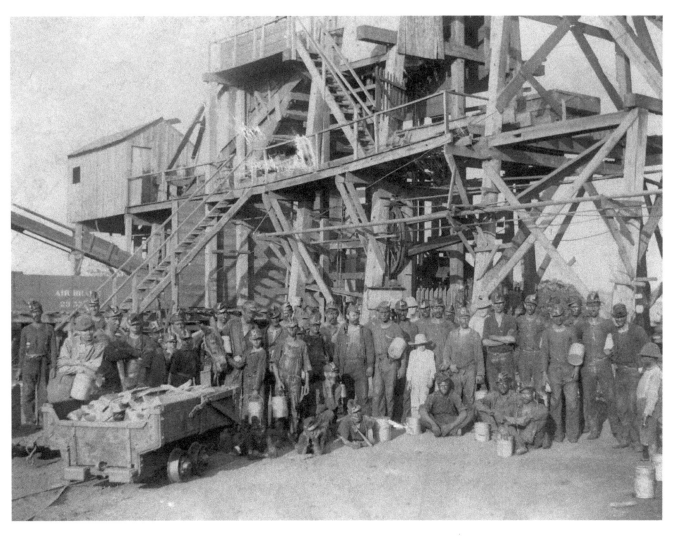

Coal mine, Wilburton, 1902. Coal mining was one of the earliest industries in Indian Territory and, by the time of this photo, was well-developed with several railroads, ready markets, and an immigrant labor force. And with minimal government regulation, the mines were some of the most dangerous in America.

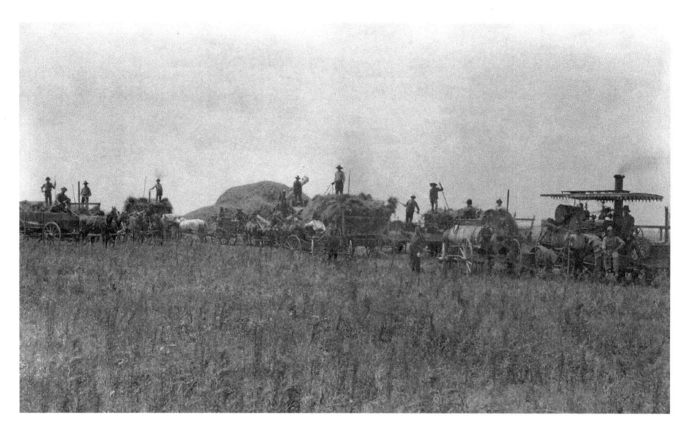

Wheat harvest near Geary, ca. 1903. Despite iconic associations of harvest with the fall season, harvest in Oklahoma comes in late spring. The wheat harvest was usually a community enterprise, and neighbor helped neighbor until the crops were all in. Mechanization would change all that, not long after the scene in this photo.

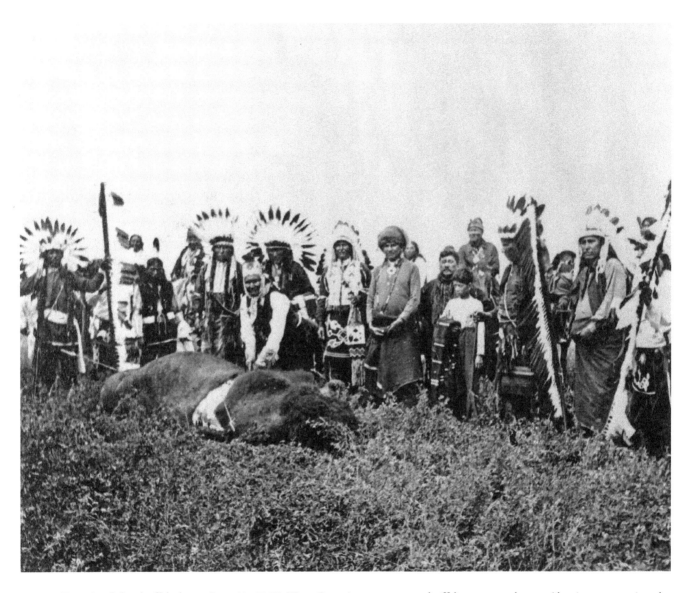

Geronimo's last buffalo hunt, June 11, 1905. Here Geronimo carves up a buffalo at a staged event (despite protestations by conservation-minded President Theodore Roosevelt) for a National Editorial Association convention at the 101 Ranch. One account has "the Apache terror" killing the beast from the front seat of a car.

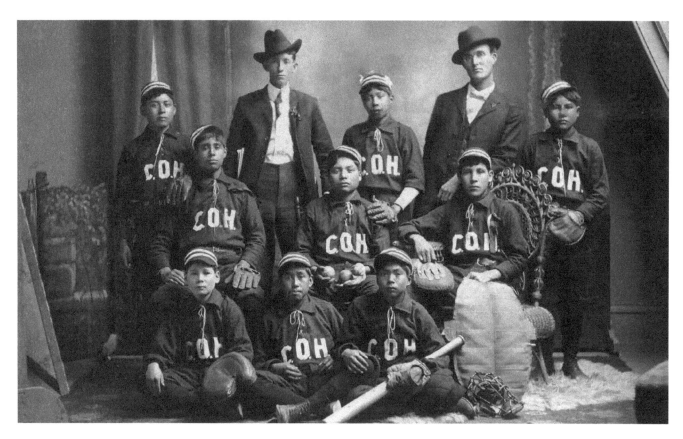

Constructive play was a new trend in education at the end of the nineteenth century and was widely adopted by the faculties of tribal boarding schools and orphans' homes in Indian Territory. The baseball teams of the Creek Orphans' Home, such as this one photographed in 1904, were quite formidable.

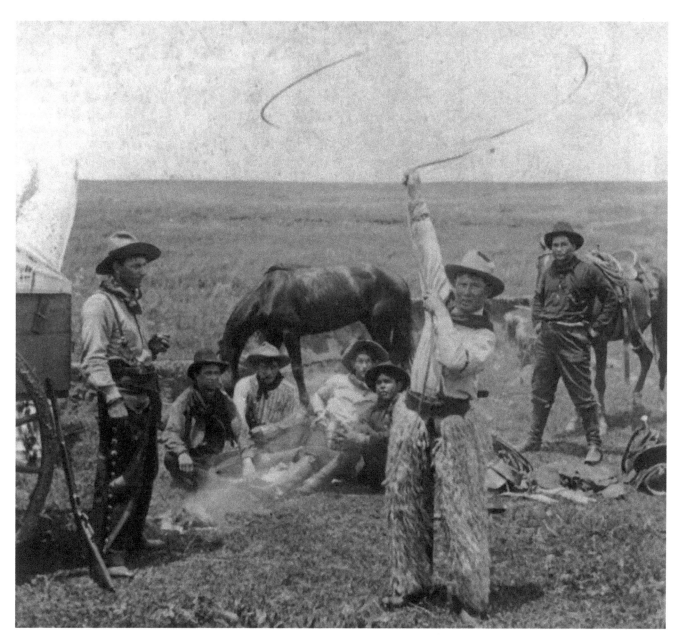

Despite the rapid settlement of Oklahoma in the two decades after the first land run, thousands of acres of ranchland remained. Times could be quite boring on the range, and storytelling, songs, and rope tricks (as seen here in 1905) helped sharpen the dull edges of life in the saddle.

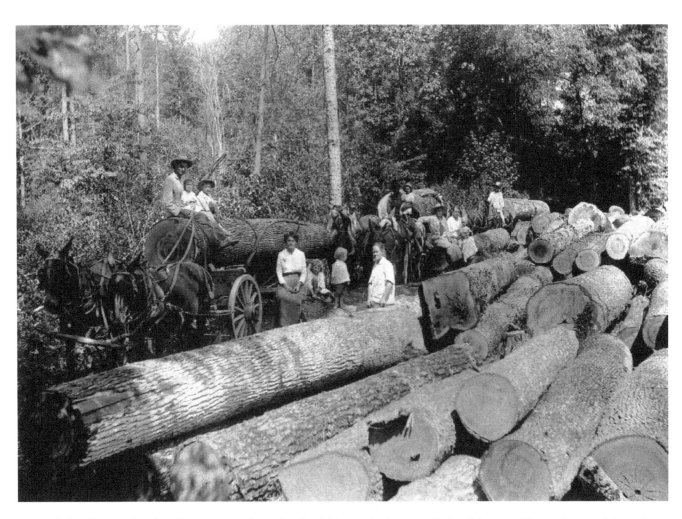

In 1906, the Choctaw Lumber Company was formed and quickly acquired near exclusive rights to millions of acres of virgin forest in the Choctaw Nation. Logs like these were hauled by mules to the company railroad and moved by rail to company mills in Broken Bow and Wright City.

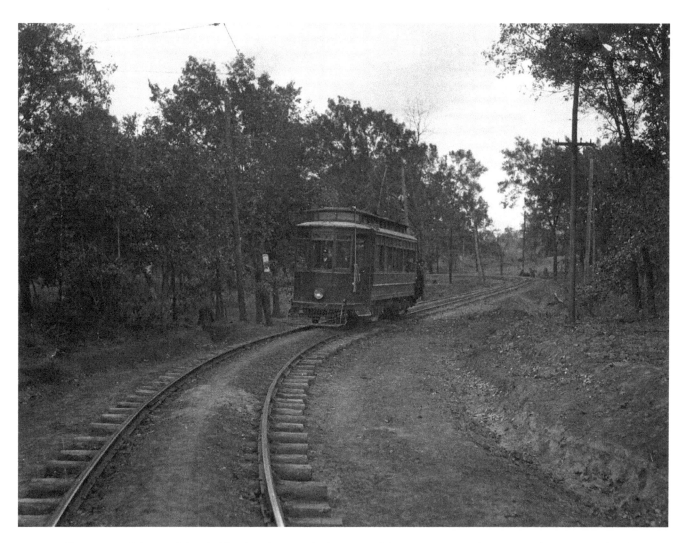

Shawnee and Tecumseh battled for decades over the location of the Pottawatomie County seat, but in 1906 the Shawnee-Tecumseh Traction Company connected the two towns and brought a measure of amicability. The trolley cars snaked through the forests between Shawnee and Tecumseh until 1932—just after Shawnee won the county seat in an election.

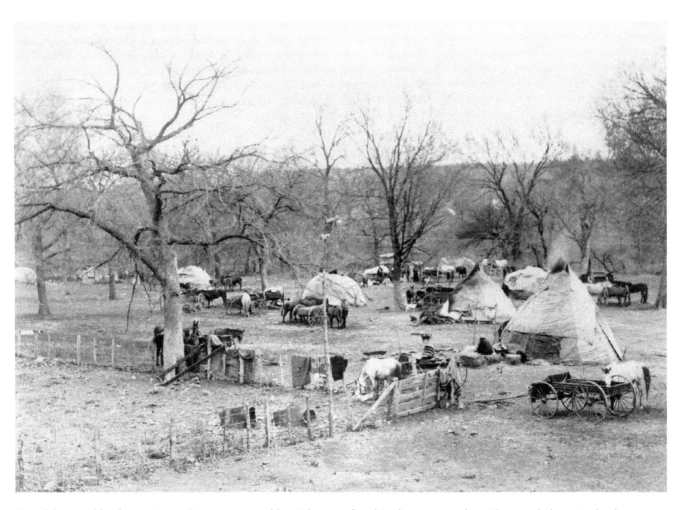

Peaceful scenes like this one in an Osage camp would vanish soon after this photo was made, as Osage tribal grazing lands were divided into private allotments in 1906, and the discovery of oil would bring challenges to the tribe's way of life.

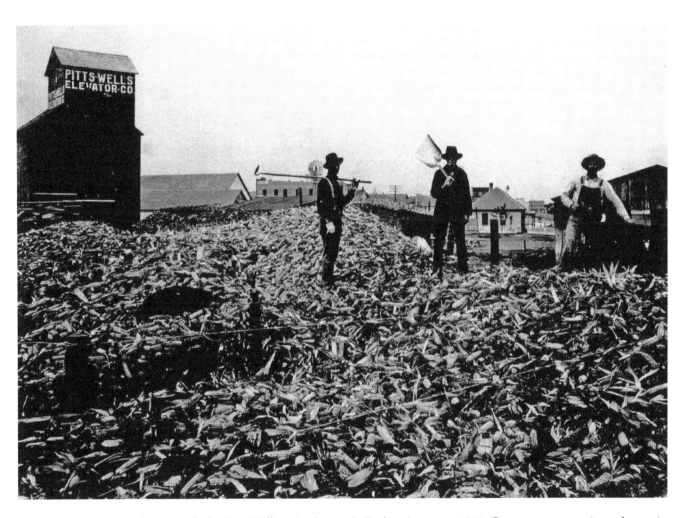

Teeming corn bins outside the Pitts-Wells grain elevator in Broken Arrow, ca. 1907. Corn was once a major cash crop in Oklahoma, until the development of large wheat farms in the west. Corn farming in Oklahoma never quite recovered from the migrations of farmers leaving the state during the Depression.

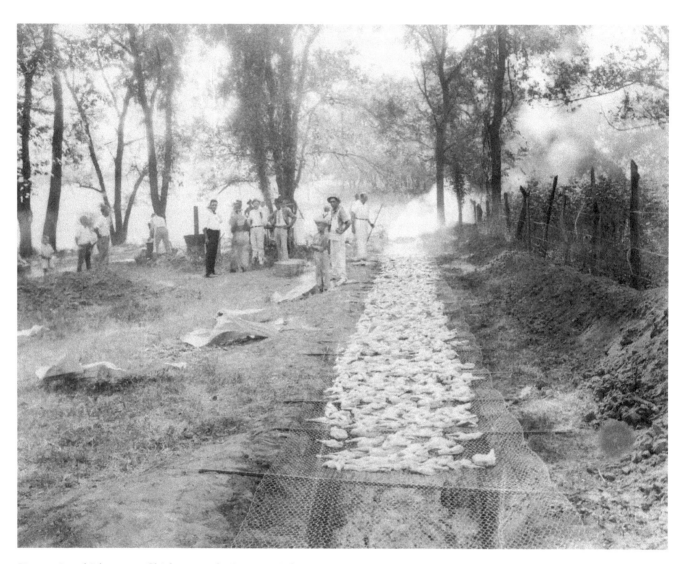

Pit-roasting chickens at a Chickasaw gathering near Ardmore.

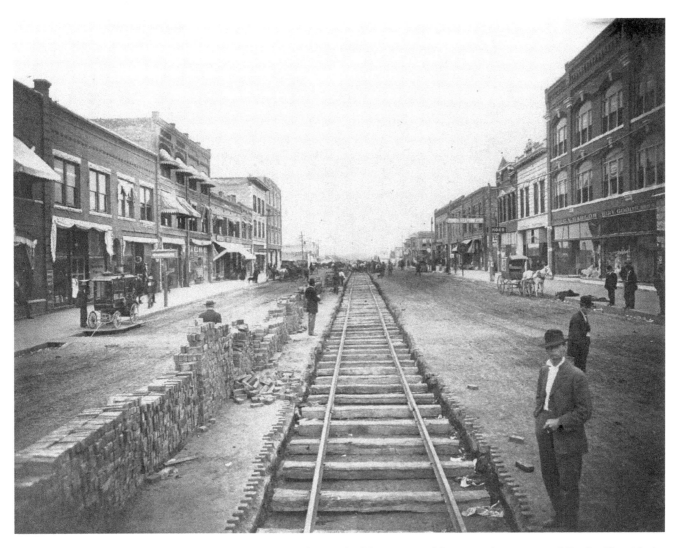

Construction of the Bartlesville Interurban Company tracks on Third Street, 1908. The interurban connected Bartlesville with the nearby industrial towns of Tuxedo and Dewey. With only 10 miles of track, the interurban couldn't keep up with Bartlesville's oil-fueled boom, and the streetcars ran for the last time in 1920.

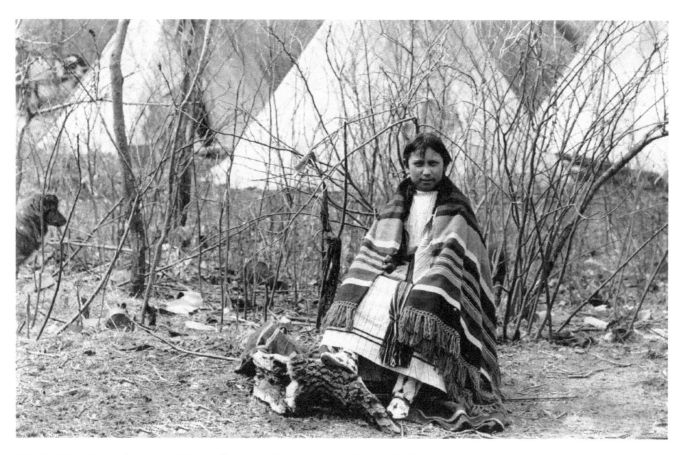

Minnie Chips is seen here in traditional Cheyenne dress, ca. 1908. She was likely a student at the United States Indian School in Canton.

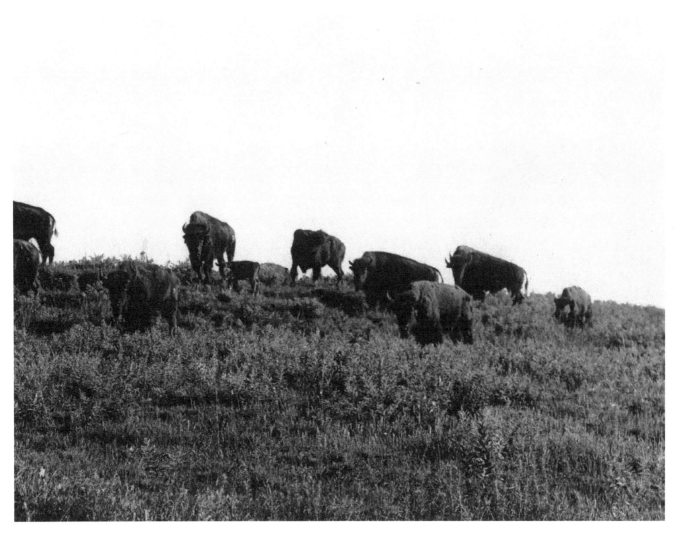

Buffalo herd, probably in the Wichita Mountains Wildlife Refuge, ca. 1908. At the time, only a few dozen buffalo remained from the tens of millions that once roamed the plains. In 1905 President Theodore Roosevelt placed in the refuge a herd from which other herds grew, and today there are over 350,000 buffalo in the United States.

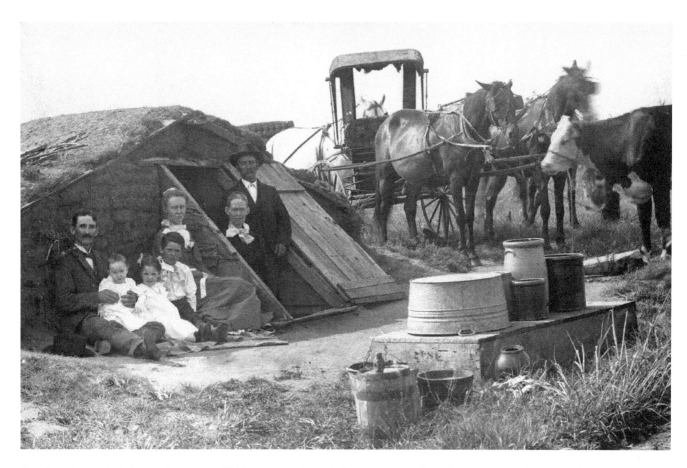

Seen here is a typical dugout in western Oklahoma, ca. 1909. A dugout was usually only a temporary housing solution, pursuant to "proving" one's claim on a homestead, to be replaced by a frame house when possible. There were many nuisances associated with living underground, including the occasional worm dangling from the ceiling.

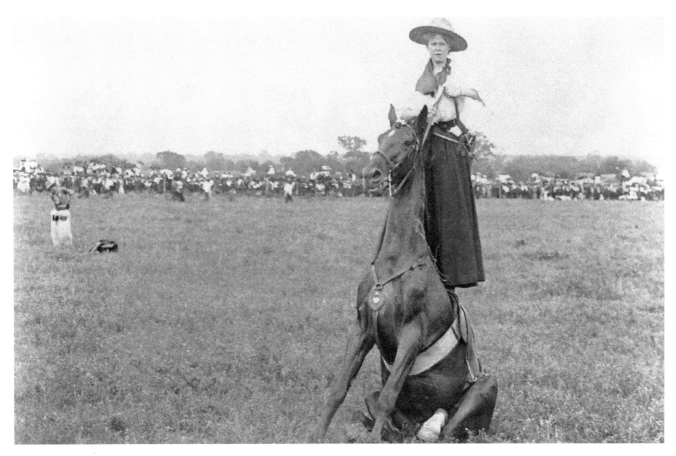

Lucille Mulhall performs at the Miller Brothers' famous 101 Ranch south of Ponca City, ca. 1909. Theodore Roosevelt called her "America's first cowgirl" after he saw her perform as a young girl at her father's ranch. She went on to a brilliant career performing riding and roping tricks in Wild West shows, but unlike Will Rogers, she never made the leap to film.

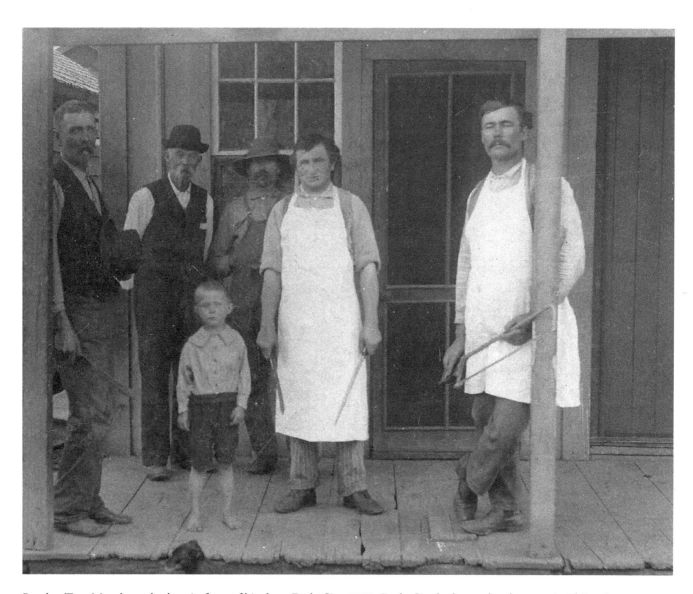

Butcher Tom Murphy and others in front of his shop, Eagle City, 1909. Eagle City had an early advantage in Blaine County because of its position on the Frisco Railroad, but when the Kansas City, Mexico and Orient Railway (later bought by the Santa Fe) built a parallel line through Longdale, Eagle City dried up.

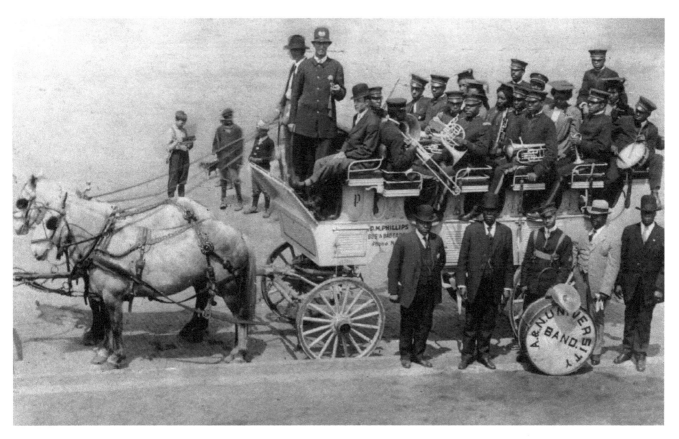

The band from the Colored Agricultural and Normal School (later Langston University) boarding a bus. This was probably part of the statewide tour the band made in the spring of 1910.

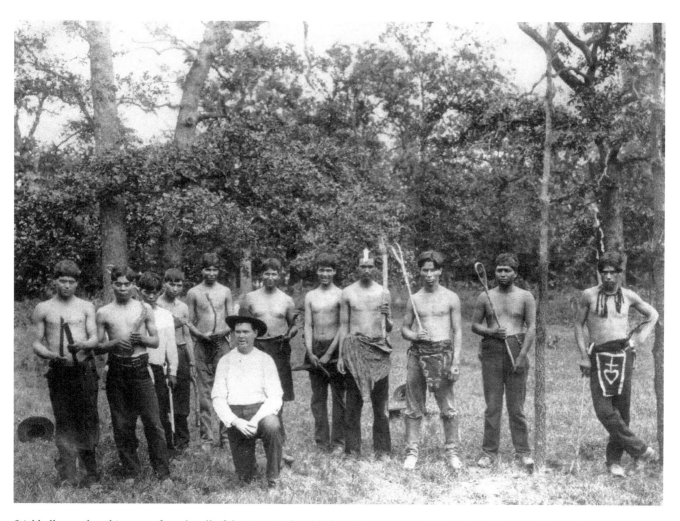

Stickball was played in some form by all of the Five Civilized Tribes. The games could be quite violent, and in ancient times opposing chiefs sometimes staged stickball games instead of waging war. Seen here is a Seminole stickball team around 1910.

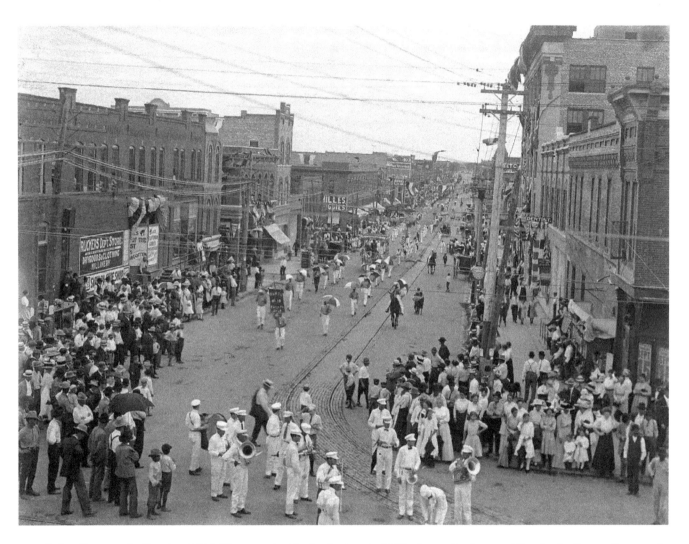

Labor Day parade, Sapulpa, 1910. The town had its beginnings in 1850 when a Creek named Sapulpa built a trading post in the area. The arrival of the Frisco Railroad in 1886 and the discovery of the Glen Pool oil field in 1905 gave Sapulpa a period of sustained growth that lasted until the Depression era.

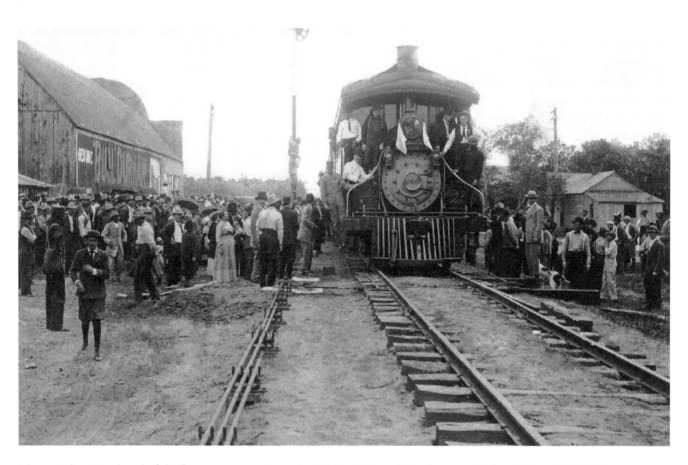

The arrival in Woodward of the first passenger train on the Wichita Falls and Northwestern Railroad, May 9, 1912. The mayor drove in a ceremonial gold spike, and citizens tossed pennies on the track for flattened souvenirs. The new route allowed northwestern Oklahomans to get to the state capital without going through Kansas.

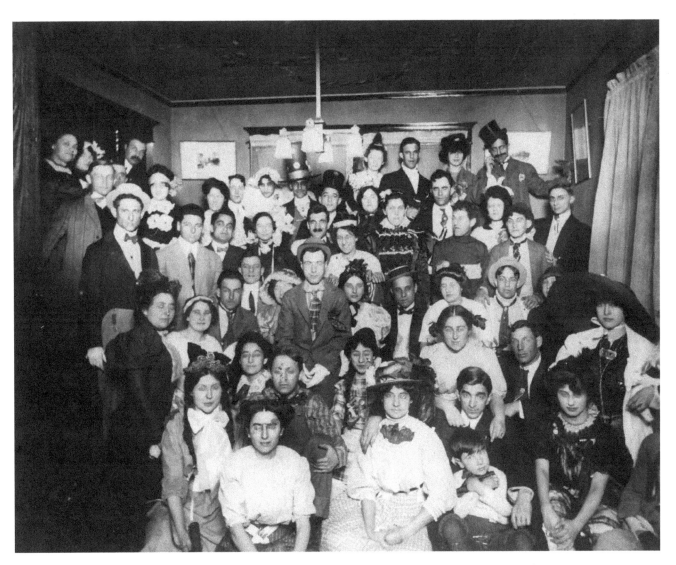

Members of Oklahoma City's Emanuel Synagogue celebrate Purim with a traditional costume party, ca. 1915.

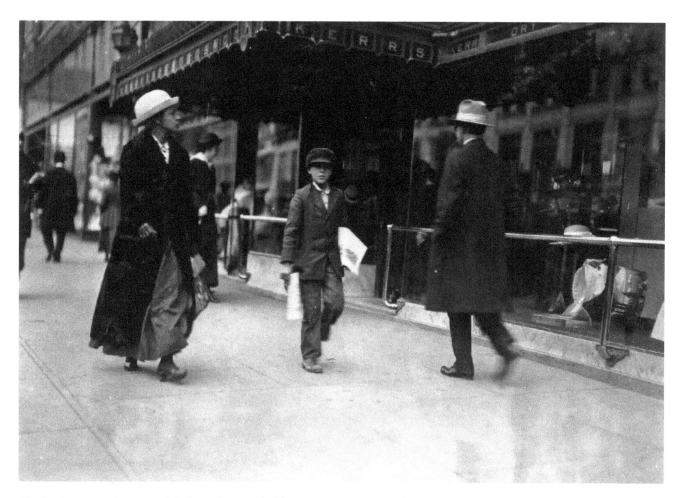

Charlie Scott was nine years old when photographed by Lewis W. Hine outside Kerr's Department Store in Oklahoma City in 1917. The newsboy admitted being truant, stating, "I dunno where the school is." Hine was an investigative photographer working for the National Child Labor Committee when he captured this and other images throughout Oklahoma in March–April 1917.

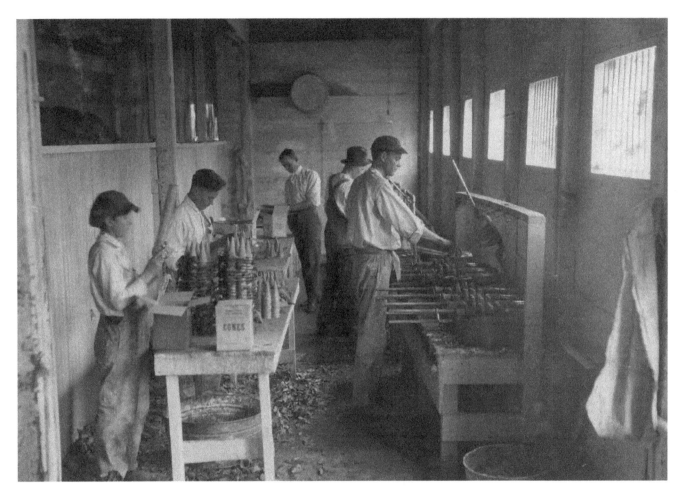

Inside the workshop of the Sanitary Ice Cream Cone Company at 116 South Dewey, Oklahoma City, April 1917. The two boys are 14 and 12 years old. Of the younger boy, his boss said, "He wasn't going to school, so I took him."

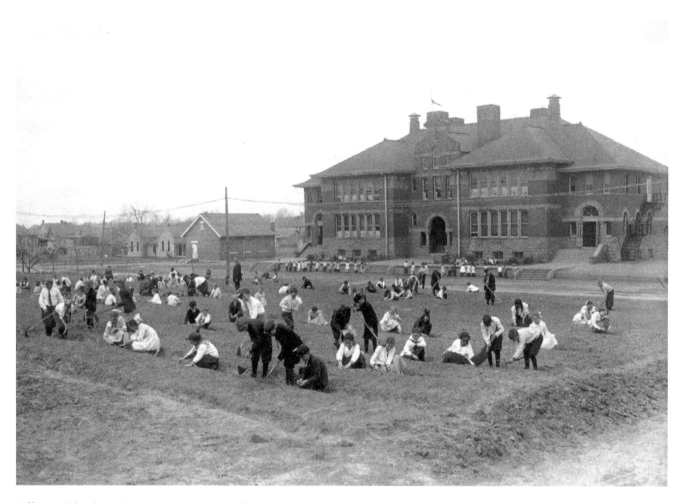

Jefferson School, Muskogee, March 1917. Jefferson served the children on Muskogee's southwest side. Here children work in the school garden.

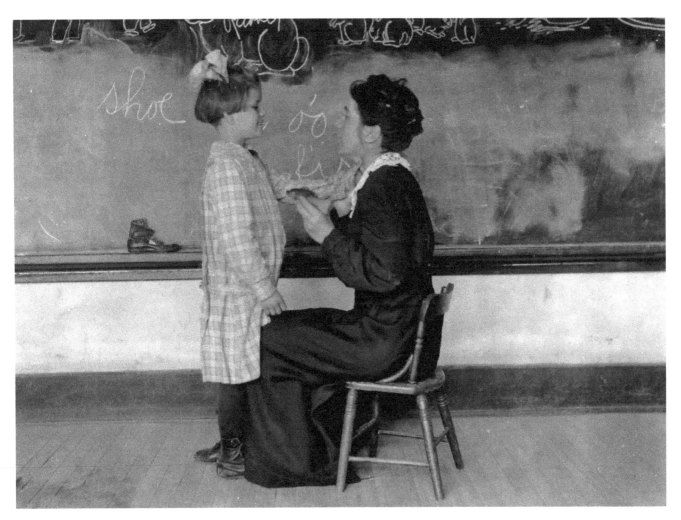

A teacher works with a young student at the Oklahoma School for Deaf Mutes near Sulphur, April 1917.

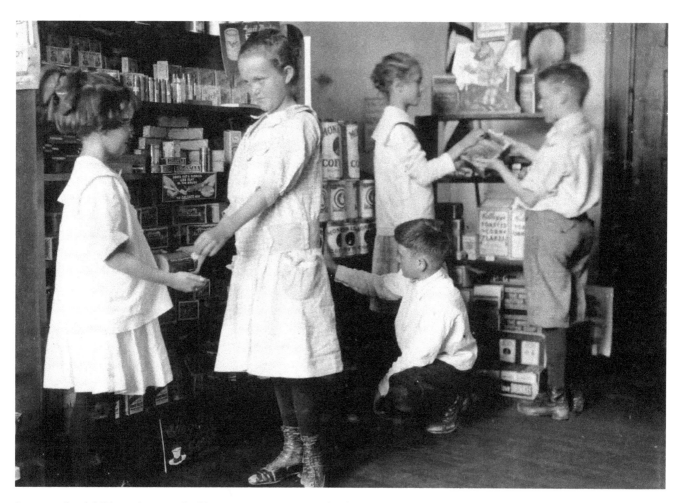

Lawton schoolchildren photographed by Lewis W. Hine in a school store, April 1917. The name of the school was not recorded, but is probably Washington School.

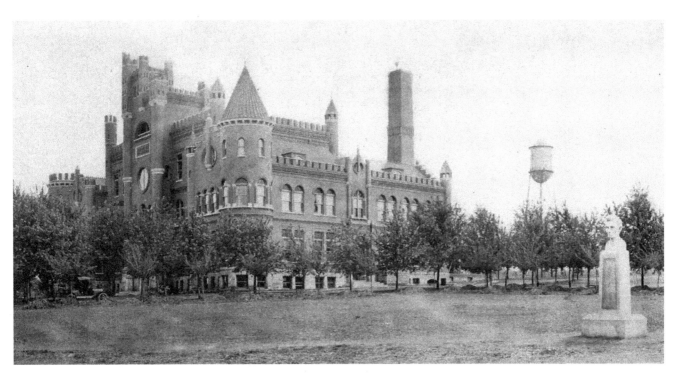

Seen here in 1918, this sprawling "Castle on the Hill" was designed by architect Joseph Foucart for the Northwestern Normal School (now Northwestern Oklahoma State University) in 1898. Though destroyed by fire in 1935, the Castle is still a revered icon of the Alva school.

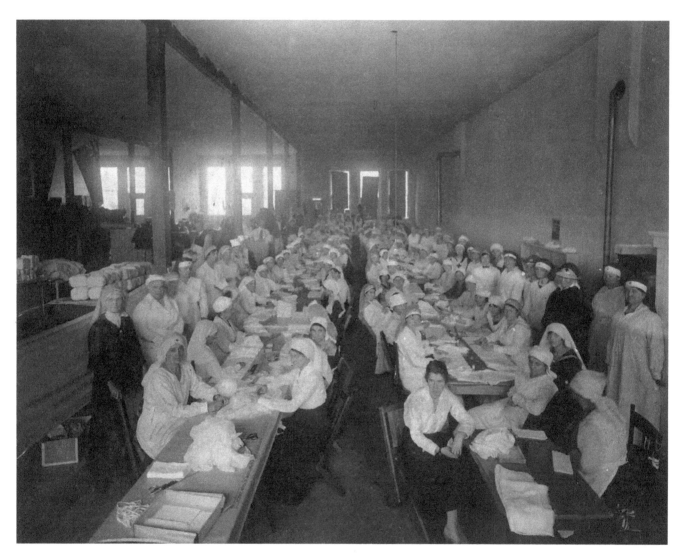

American Red Cross workers in Muskogee during World War I. Women volunteers made millions of bandages and socks for soldiers fighting the Germans, but by war's end, the volunteers were mobilized to fight an entirely different enemy: the Spanish influenza.

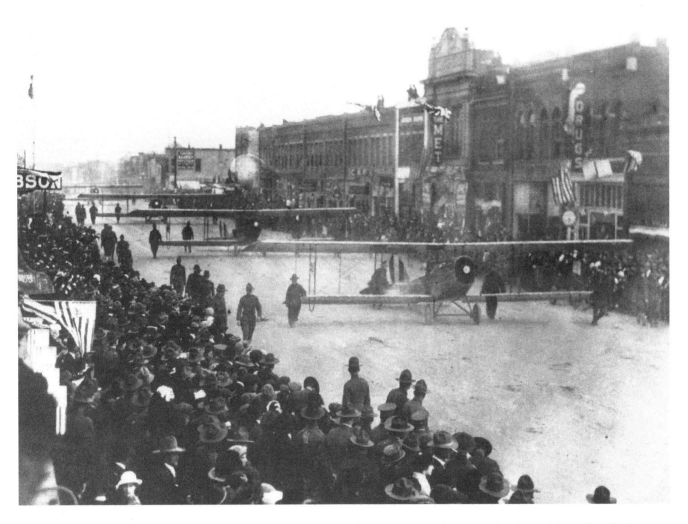

Armistice Day parade in Lawton, November 16, 1918. More than 40,000 people were on hand to celebrate the Allied victory in World War I. Included were nine regiments of artillery, six military bands, and 50 airplanes. The planes likely were from the Army's first aviation base, Post Field on the Fort Sill reservation.

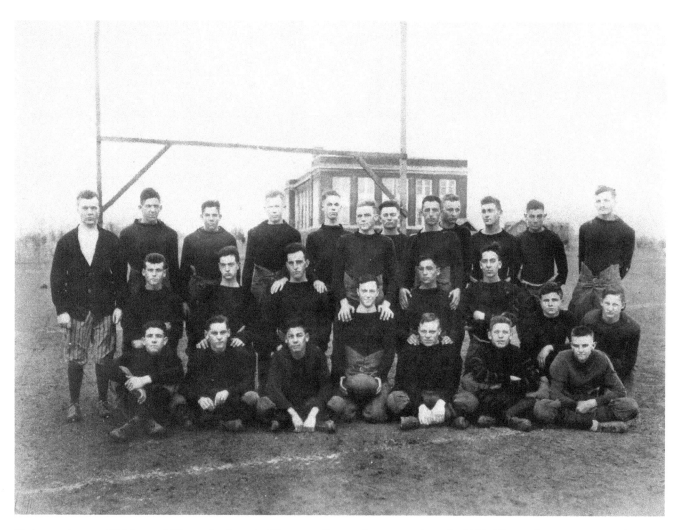

Cadets at the new Oklahoma Military Academy in Claremore line up for a team photo in 1920. The academy was a powerhouse in football in its first years of existence.

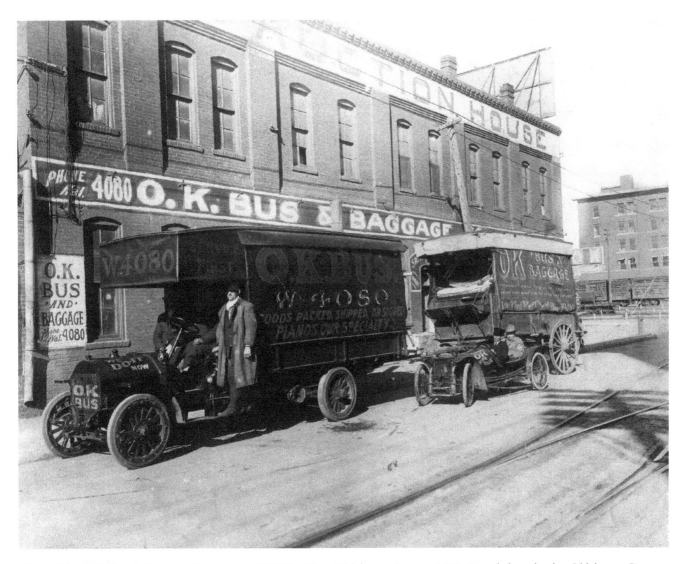

Vans of the O.K. Bus & Baggage Company at 300 West First, Oklahoma City, ca. 1920. Founded on the day Oklahoma City was established, O.K. was a fixture on city streets for decades.

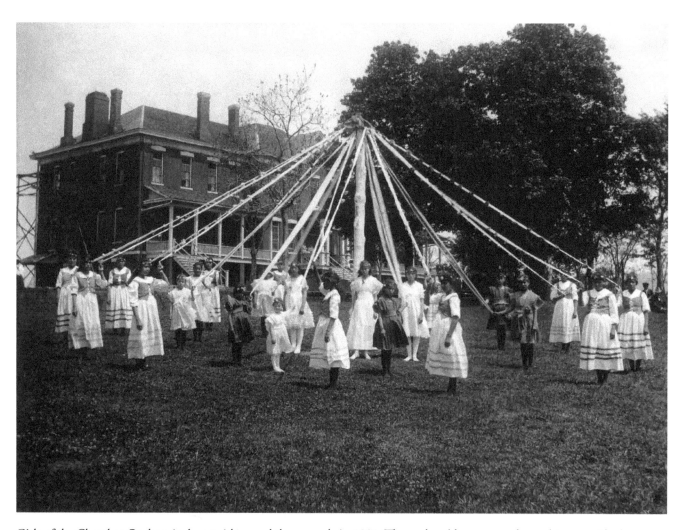

Girls of the Cherokee Orphan Asylum twirl around the maypole in 1921. The orphans' home was relocated just outside the Cherokee capital of Tahlequah after a disastrous fire destroyed the original building near Salina.

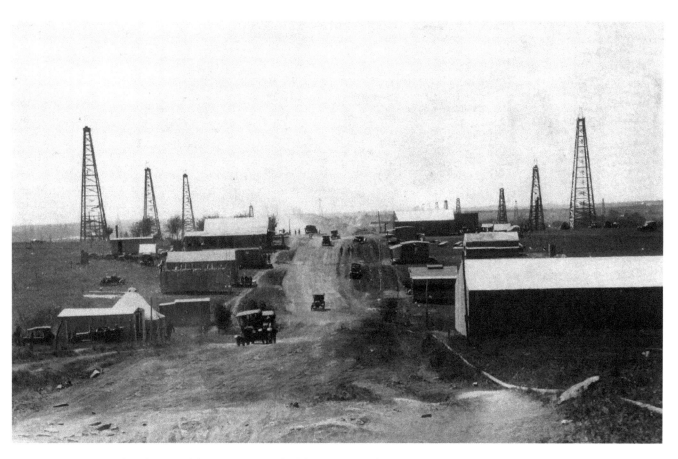

West Duncan Oil and Gas Field, 1921. Duncan had been a successful market town for over 30 years when this large field was discovered in 1918. Duncanites were able to resist the oil-boom fever and maintain steady growth for decades. Here the view is from Oil City. Gas City was just miles south.

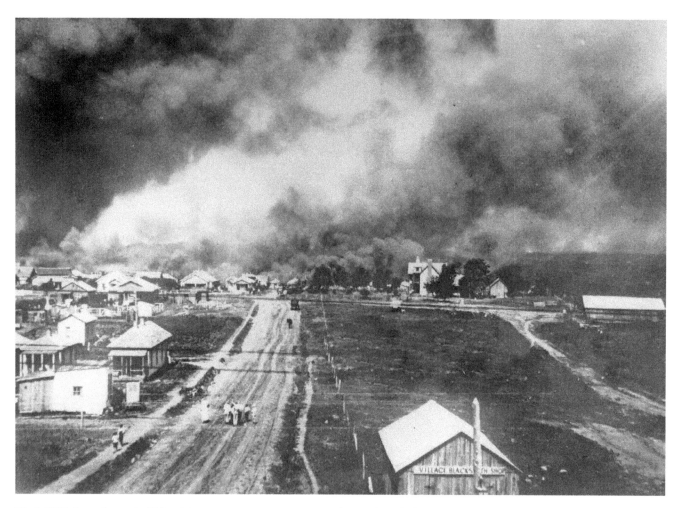

Black Wall Street burns in Tulsa, May 31–June 2, 1921. A misunderstanding fueled by hate and fanned by the city's newspaper led to a confrontation between white and black residents over the safety of a black man threatened with lynching. When the confrontation escalated, violence erupted in the prosperous African-American section known as Black Wall Street, with many homes and businesses burned. By the time the state militia had quelled the racial violence, 35 city blocks were destroyed, and many residents were dead.

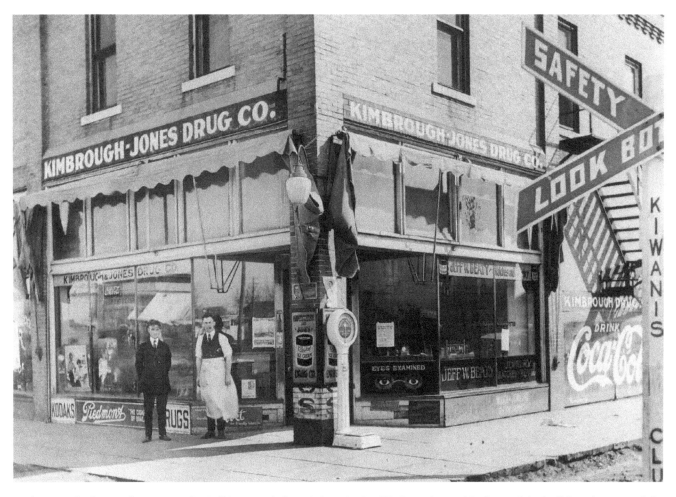

Photographed around 1921, jeweler Jeff Beaty, at left, and druggist Joe Kimbrough stand in front of the building they owned for decades at Southwest Twenty-fifth and Robinson in Oklahoma City's Capitol Hill.

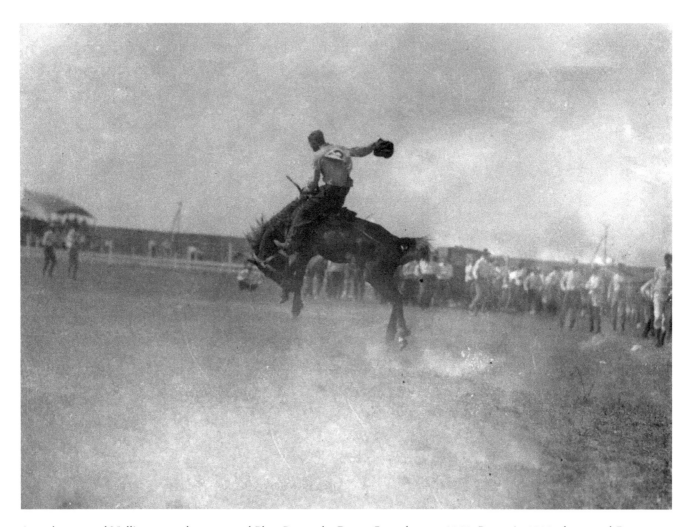

A cowboy named Nollin tames a bronc named Plow Boy at the Dewey Roundup, ca. 1922. Begun in 1909, the annual Dewey Roundup was a major event on the rodeo circuit for nearly 40 years.

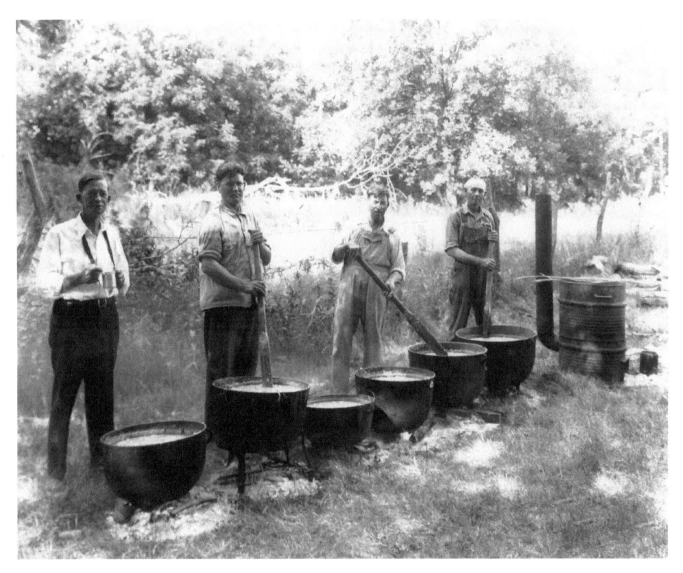

Chickasaws stir cauldrons of pashofa, a boiled mixture of cracked Indian corn and cured meat, to be served during a pashofa dance at the Chapman farm near Tishomingo, ca. 1920s. A pashofa dance is a ritual for the healing of the sick.

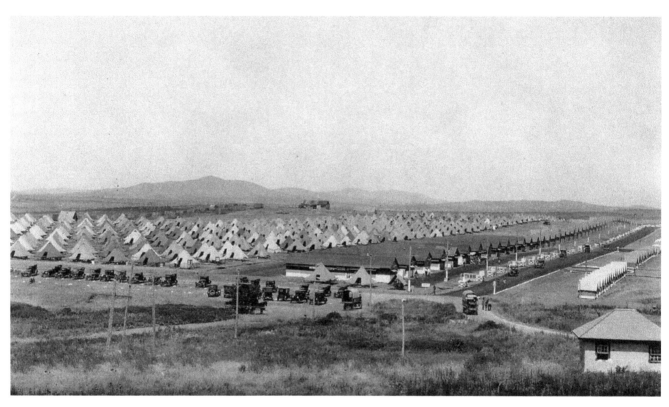

Camp Wolf, Fort Sill, 1923. This view was likely captured during the summer training exercises of National Guard units from around the country. The Guardsmen received a distinguished guest that summer in the person of General John J. Pershing.

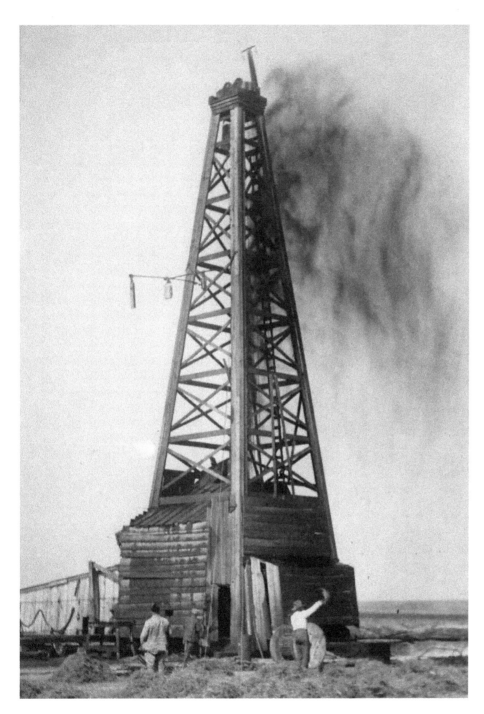

A gusher at Okemah, February 21, 1922. Unlike towns such as Duncan, which tried to manage growth during oil booms, Okemah embraced the arrival of the wildcatters wholeheartedly and even permitted drilling on city lots. This is one of the first wells to come in near Okemah.

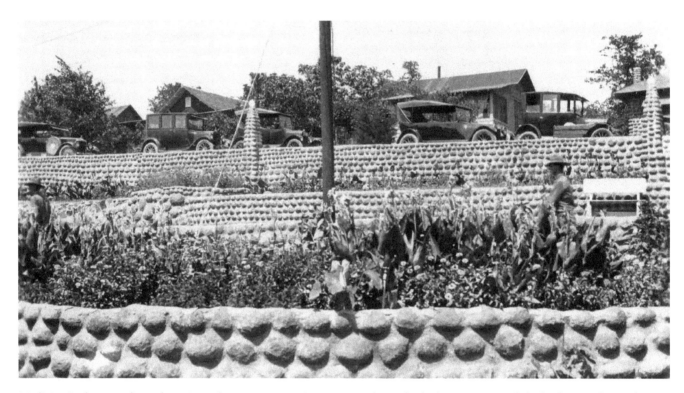

Medicine Park was a planned tourist and resort area near Lawton. Developers built the resort around the healing qualities of nearby Medicine Creek, but it was the naturally round, granite cobblestones found only in the Wichita Mountains that gave the town its unique character, as seen here in the 1920s.

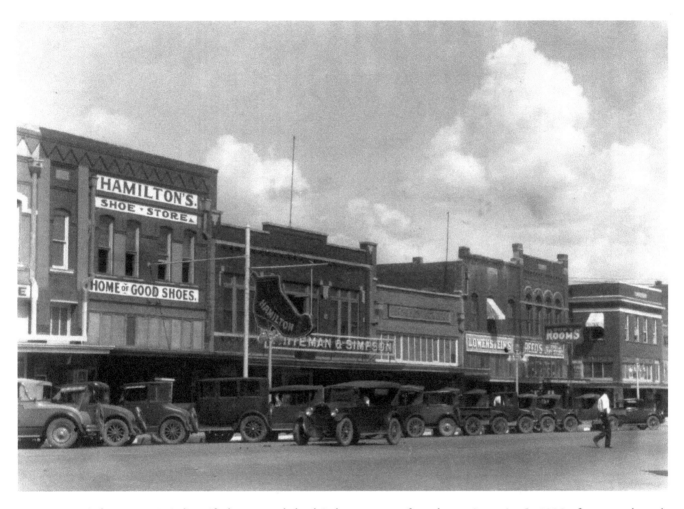

Downtown Ardmore, 1925. A diversified economy helped Ardmore recover from devastation twice. In 1895 a fire swept through the wooden buildings downtown; and in 1915 a tank car full of gasoline exploded, leveling dozens of downtown buildings and sending a river of flaming liquid through the streets, torching everything in its path.

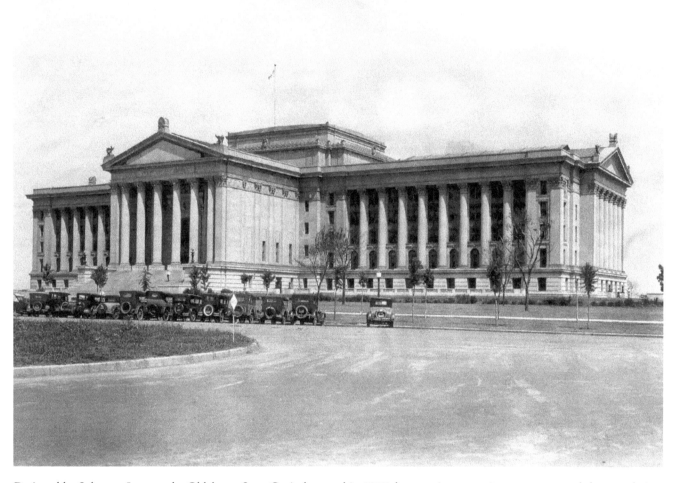

Designed by Solomon Layton, the Oklahoma State Capitol opened in 1917, but wartime penuriousness prevented the completion of the dome. The scene here is in 1926, just a few years before oil wells began sprouting on the lawns.

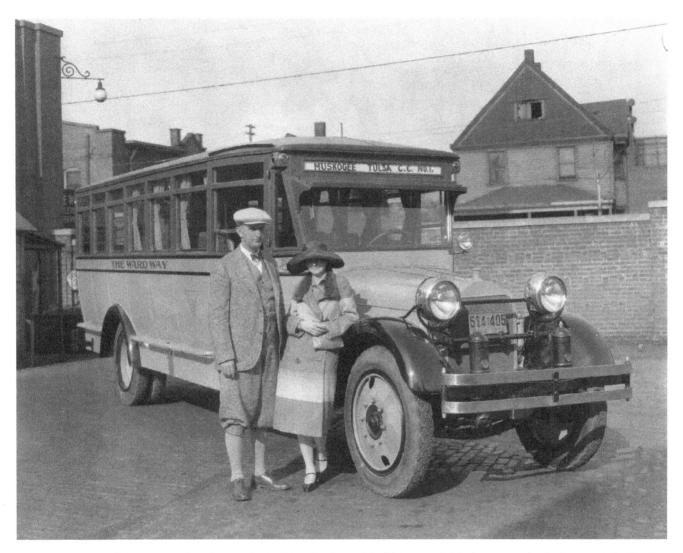

Passengers in Muskogee wait to board a Ward Way Lines bus bound for Tulsa, 1926. Muskogee was the de facto capital of Indian Territory and, until eclipsed by Tulsa in the 1920s, was the second-largest city in the state.

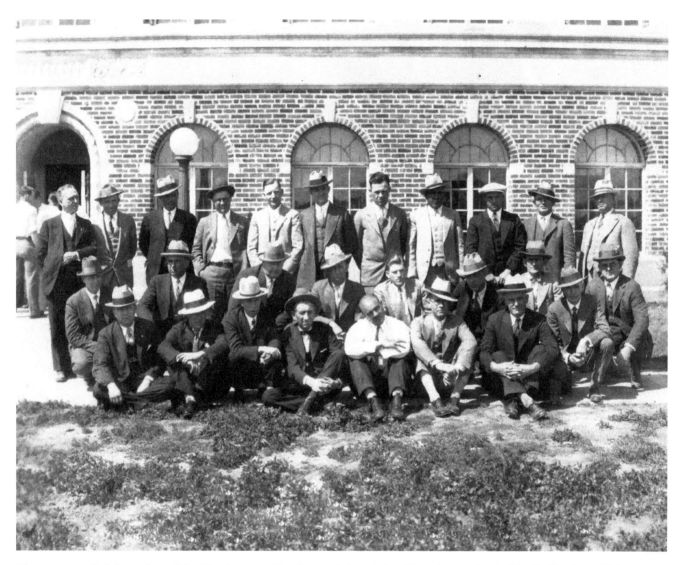

These men availed themselves of the "Southwestern Lumbermen's Association Short Course for Builders" offered at Oklahoma A&M College in Stillwater in 1928.

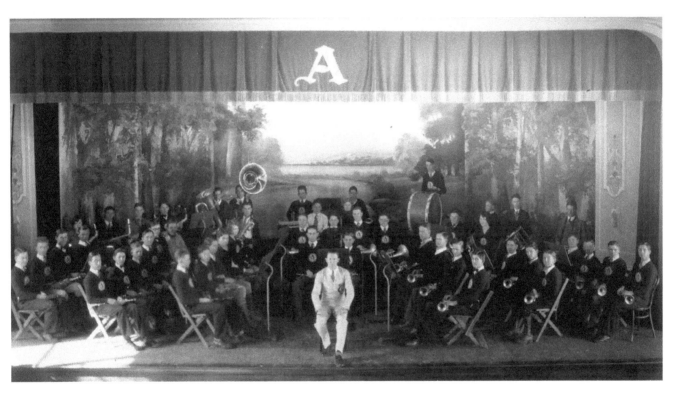

The 1929–1930 Ada High School Band poses on stage.

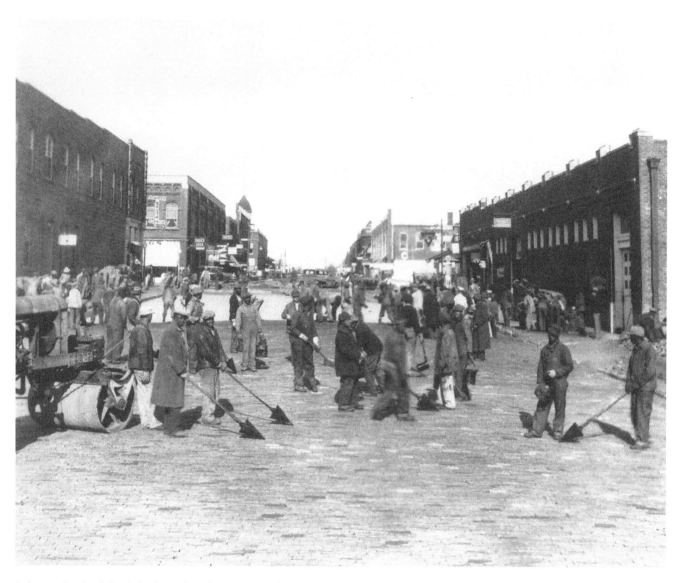

Laborers for the federal Civil Works Administration finish off a repaved section of a Guthrie street, 1933. The CWA was a temporary program established to get millions of unemployed men through the winter. The repaving work was quite difficult: laborers had to remove the bricks, clean them, roll the dirt path flat, then relay the brick.

A Curtain of Black Rolled Down

(1930–1945)

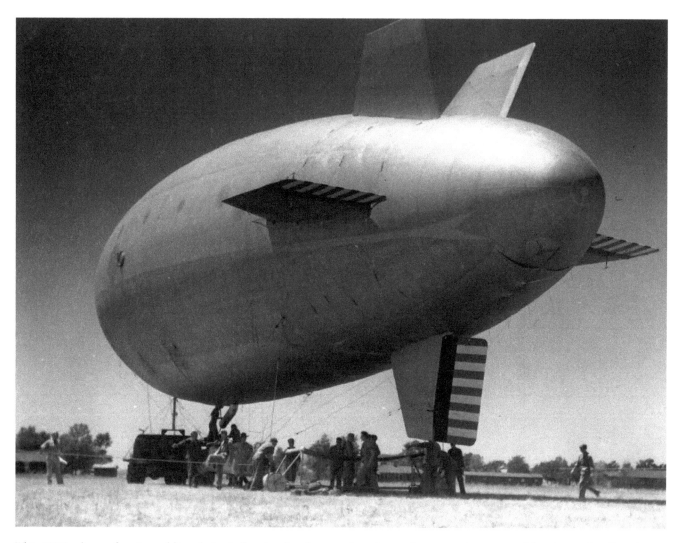

This 1930s photo of an Army blimp being inflated at Sapulpa may have been taken upon the return of Sapulpa native Captain Frank Trotter to his hometown. Trotter was an ace blimp pilot, winner of several blimp races and somewhat of a daredevil, having once delivered a stack of newspapers to the top of the Empire State Building.

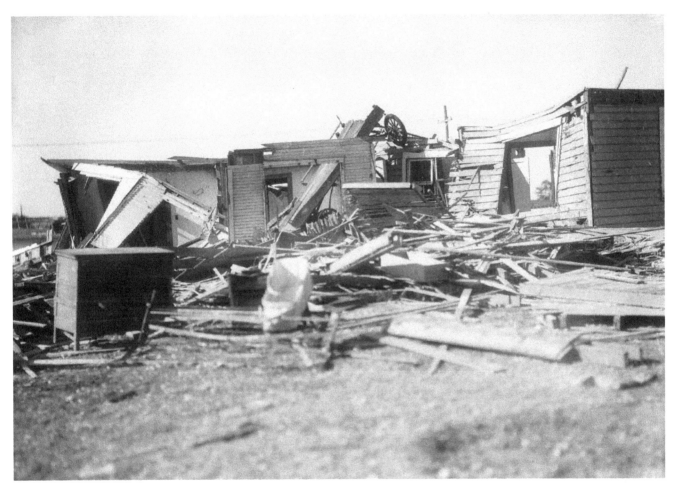

Seen here is the aftermath of a devastating tornado that struck Bethany on the afternoon of November 19, 1930. Bethany was a bustling, thriving community when the funnel touched down and wiped away most of the city in only five minutes. By nightfall, 18 were dead and 58 injured.

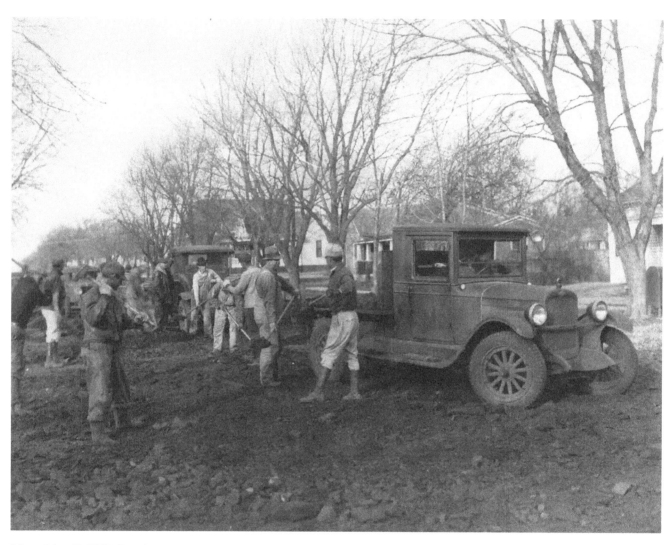

Men of the Civil Works Administration repair a city street in Yukon, 1933. The CWA was one of the earliest and costliest of the New Deal programs and ran from November 1933 through March 1934.

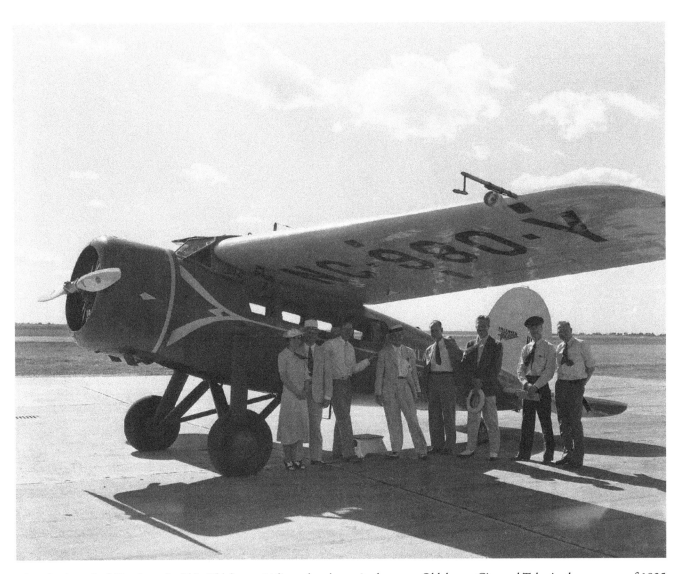

Local aviator Joel Pitts launched his Oklahoma Airlines shuttle service between Oklahoma City and Tulsa in the summer of 1935 with much fanfare. Unfortunately, the service folded around Christmas that same year. Pitts went on to have a full career as a pilot for Braniff.

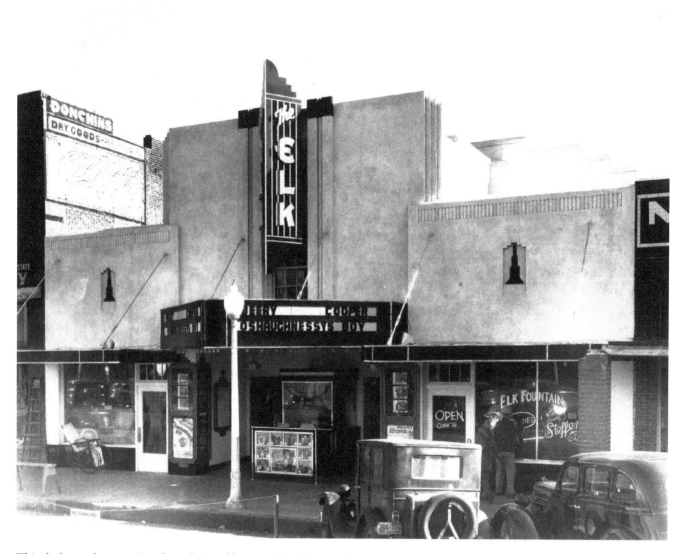

This sleek, art-deco movie palace, designed by noted Southwest architect W. Scott Dunne, has graced Elk City's stretch of Route 66 since 1935. Here the Elk is featuring the 1935 movie *O'shaughnessy's Boy,* starring Wallace Beery and Jackie Cooper.

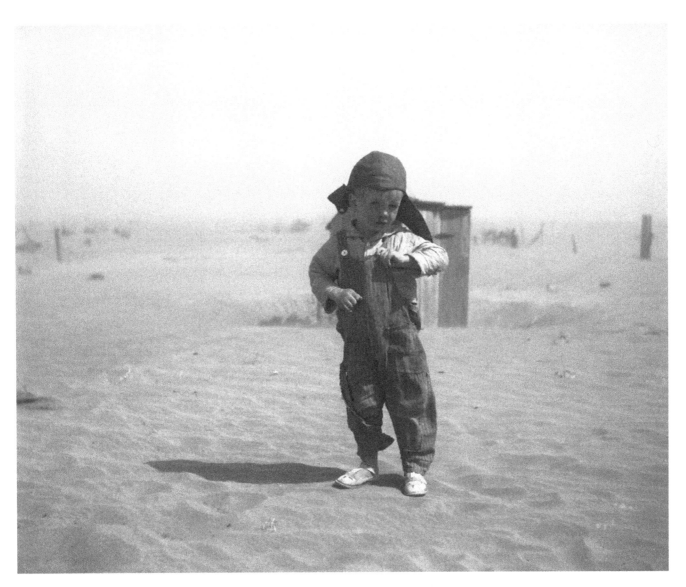

The subject of this Arthur Rothstein photo of a young boy in Cimarron County in 1936 is probably three-year-old Darrel Coble, who lived in the area his whole life and later said, "I don't really know why I like living here. I guess just 'cause this country's home."

This was the view north up Broadway from Grand during a dust storm in Oklahoma City in the mid-1930s. On one January day in 1935, a 9,000-foot-high dry wind raised the temperature from 40 to 75 degrees and coated the city in reddish-yellow dust, with visibility reduced to a half-mile.

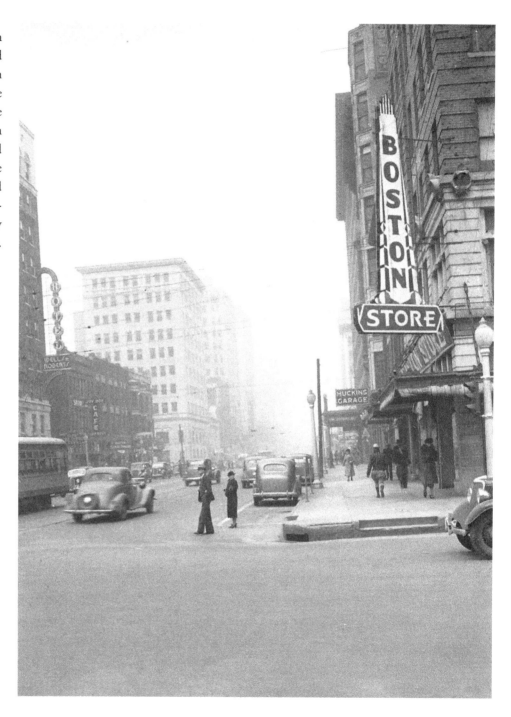

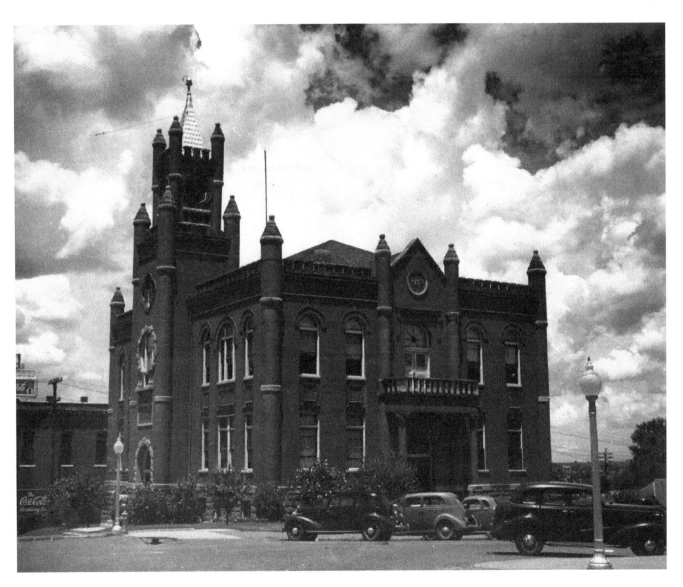

Guthrie's City Hall was designed by Joseph Foucart and erected in 1902 with an eye toward becoming the state capitol. It served as the meeting site of the state constitutional convention in 1906-7. Seen here in the mid-1930s, the ornate structure fell to the wrecking ball in 1955 after years of neglect.

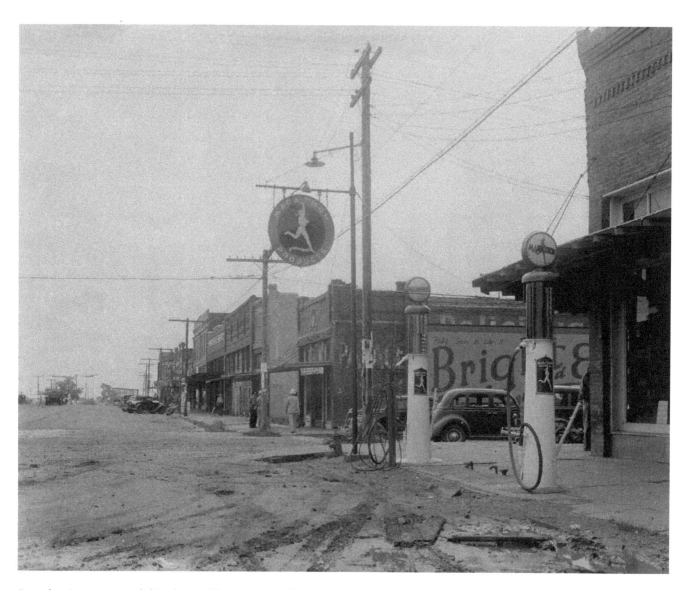

Dorothea Lange snapped this photo of downtown Caddo in 1938 to illustrate the decimation of small towns during the Okie migrations. Caddo grew up around a depot on the Katy Railroad in 1872. The Katy was the only road authorized to cross Indian Territory, and Caddo grew quickly as a market center—but only for a short while.

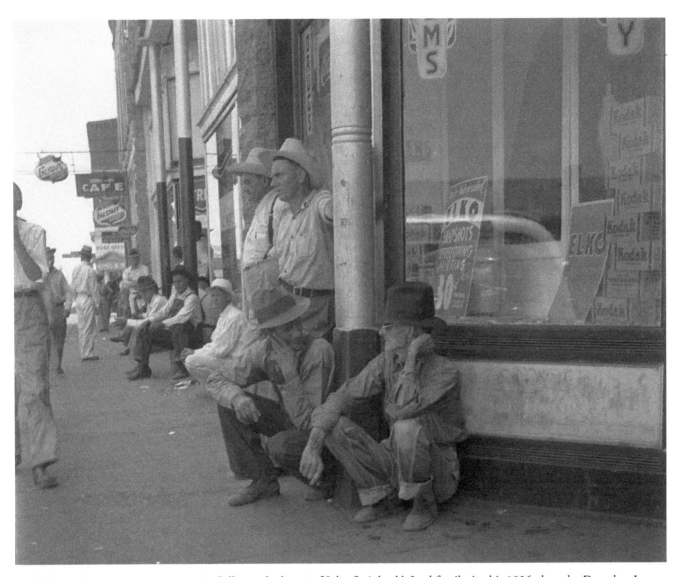

Idle farmers loiter on a street corner in Sallisaw, the home of John Steinbeck's Joad family, in this 1936 photo by Dorothea Lange. While farmers in northwest Oklahoma were beset by dust storms, farmers in the east were troubled by drought, low prices, foreclosures, and mechanization. Many left for what they thought were greener pastures out west.

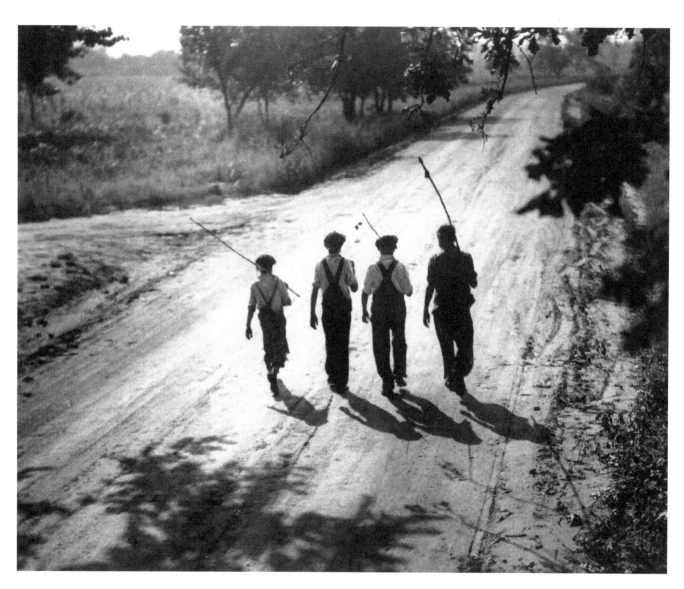

An end to innocence: boys headed for a fishing hole near Muskogee, 1937. Boys like these would experience great change in Oklahoma and the nation as they endured a childhood in the Depression and attained young manhood serving in World War II.

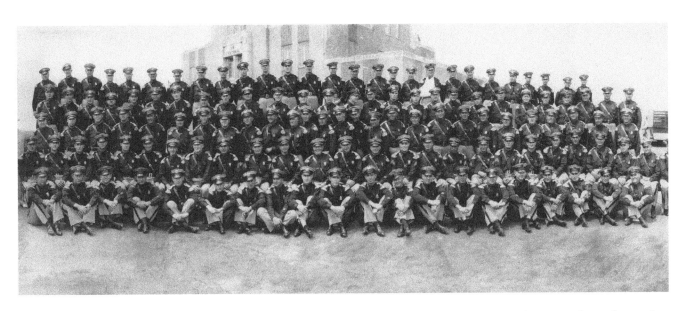

Concerned about the state's deadly roads, Governor Marland formed the Oklahoma State Highway Patrol to enforce a slew of new traffic laws in 1937. Oklahoma drivers had never had licenses or rules, so these first patrolmen, seen in 1938, were specially trained to be courteous and respectful. The tradition continues today.

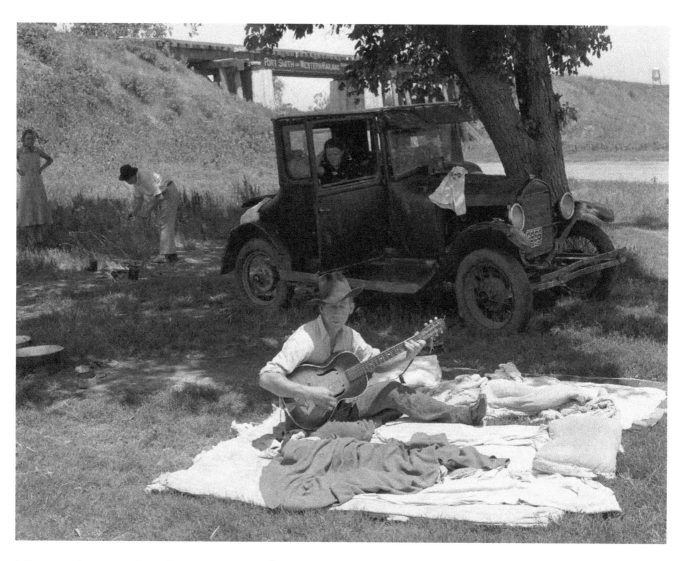

Migrant workers camped near Prague, 1939. Not all migrants went west to work in California's fields; many roamed the Southwest picking up government jobs or performing odd jobs to carry them to their next meal. Photographed by Russell Lee, this fellow evokes the image of another Oklahoman, Woody Guthrie.

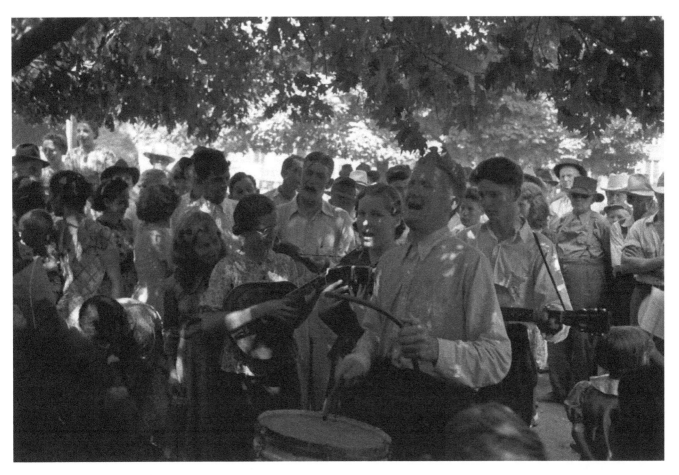

Oklahoma was settled largely by adherents to evangelical movements in mainstream Protestant denominations, and a number of newly formed ones as well. Revivals, like this one in Tahlequah in 1939, were a common sight throughout the state, but especially so during the challenging times of the Depression.

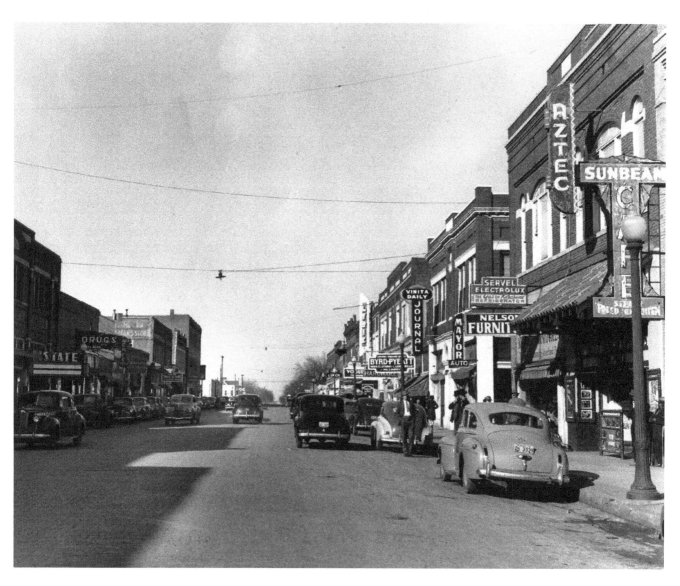

Route 66 as it passes along Vinita's Wilson Street in 1939. Established along the Katy Railroad in 1872, Vinita was one of the first towns in the state to incorporate.

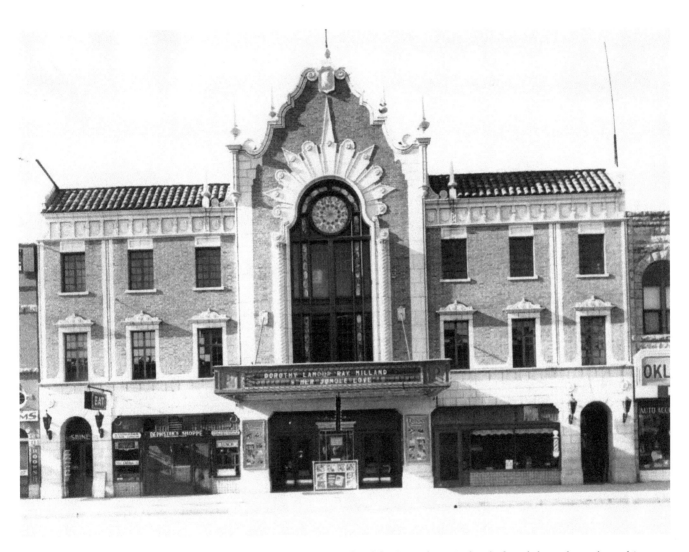

The Poncan Theatre, seen here around 1938, is a fine example of the Spanish Revival style found throughout the architecture of Ponca City's golden era. The theater was built to accommodate silent movies, but talkies debuted the same week it opened in 1927. The Poncan is still an active theater for plays and films.

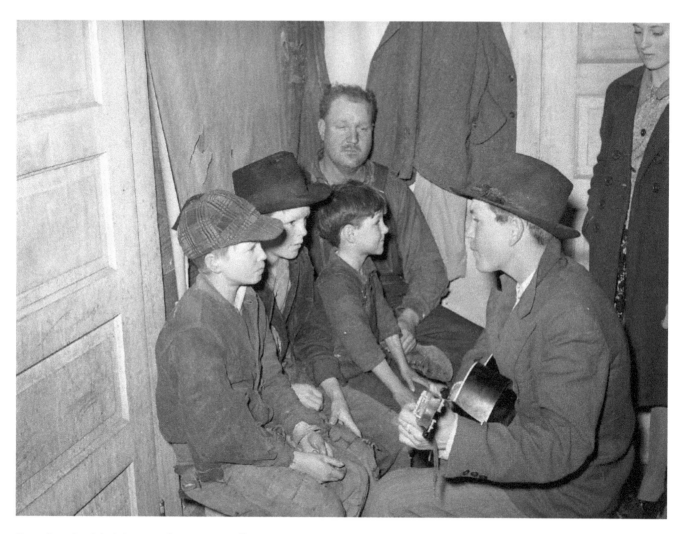

Farm Security Administration lensman Russell Lee captured this scene during a community gathering in McIntosh County, 1939. The barn dance and the play party were folk traditions carried to Oklahoma by its earliest settlers, and many such entertainments continued into the 1950s before urbanization began to diminish them.

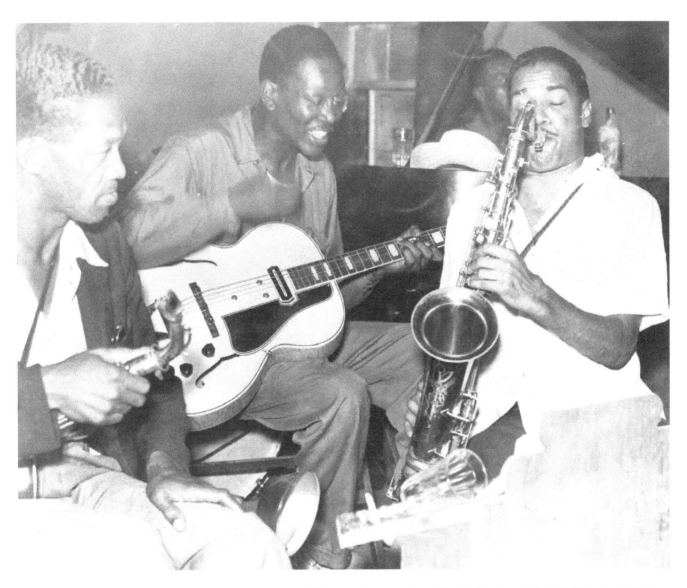

Jazz guitar legend Charlie Christian, who grew up in Oklahoma City, reunites with old friends at Ruby's Grill in the city's Deep Deuce following a tour with Benny Goodman, 1940.

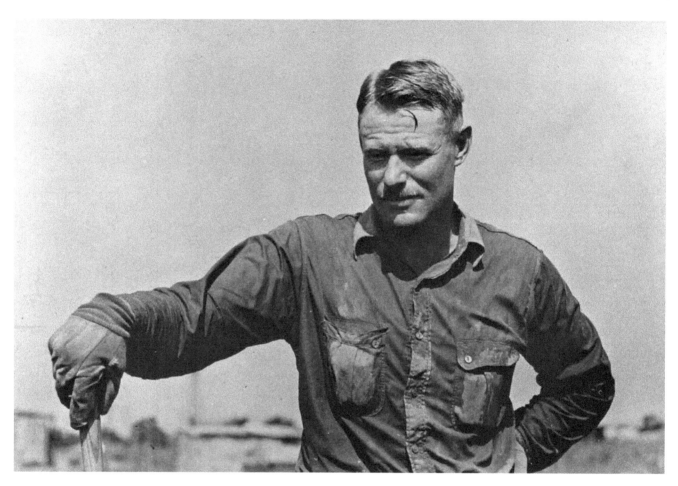

The oil industry buffered the state's economy from some of the worst effects of the Depression by offering employment to thousands of workers. As this roustabout in the Seminole Field would attest, most of the work was difficult, dirty, and dangerous, and living conditions were often squalid.

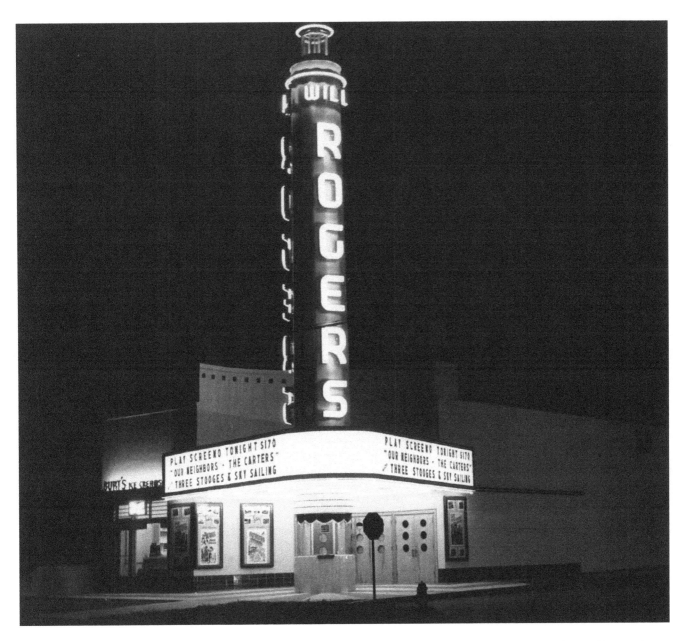

Tulsa's Will Rogers Theatre was a fixture on Eleventh Street from 1941 to 1976. Its sister theater, also designed by Southwest architect Jack Corgan, still stands in Oklahoma City on Western Avenue.

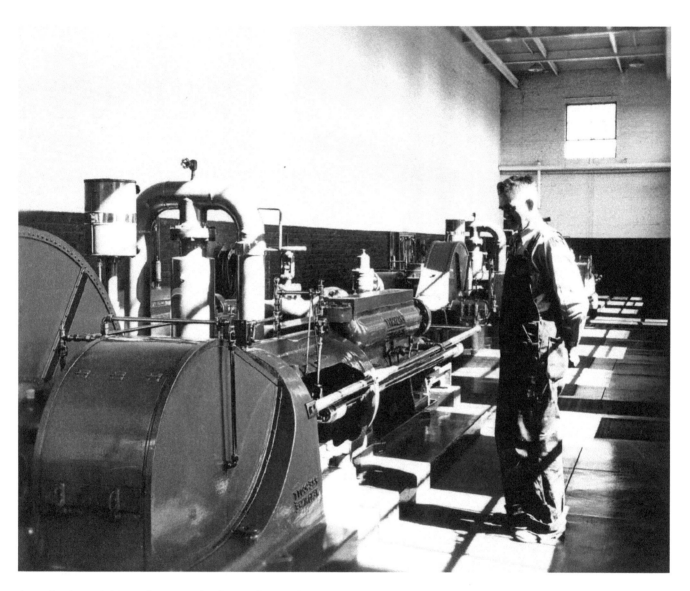

A mechanic tends his machinery at the Great Lakes Pipeline pumping station in Tulsa, November 1942. The station was one of five in the state that pumped gasoline to Ponca City and from there to Chicago and the upper Midwest. At the time, the 1,400-mile route was the longest gasoline pipeline in the world.

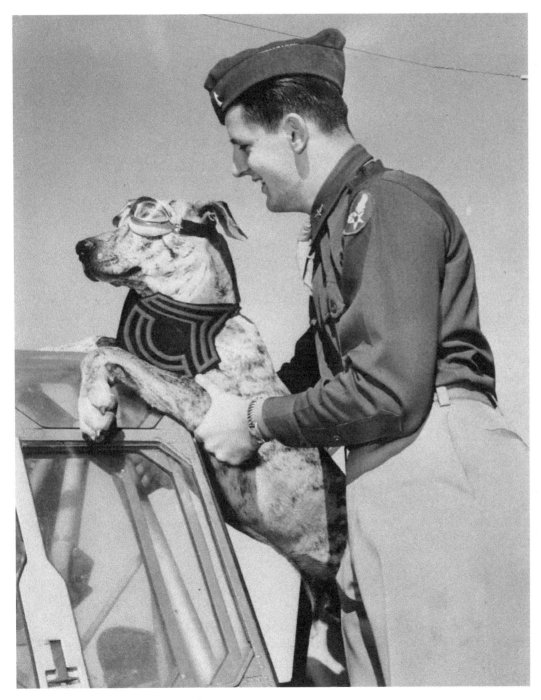

Tiger, a Great Dane mascot at the Enid Army Flying School, earned his sergeant's stripes by waking the men in his barracks every morning. Here, in 1942, Lieutenant Robert Davidson poses with Tiger next to a plane at what would become Vance Air Force Base in 1948.

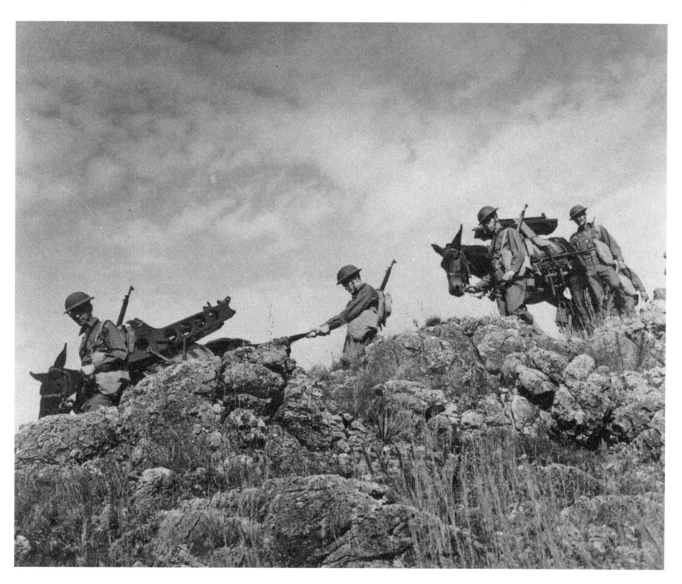

Pack mules train with artillerymen at Fort Sill in 1942. Training in the rugged Wichita Mountains proved to have been quite useful when American soldiers in World War II moved into similar terrain during the Italian campaign of 1943-44.

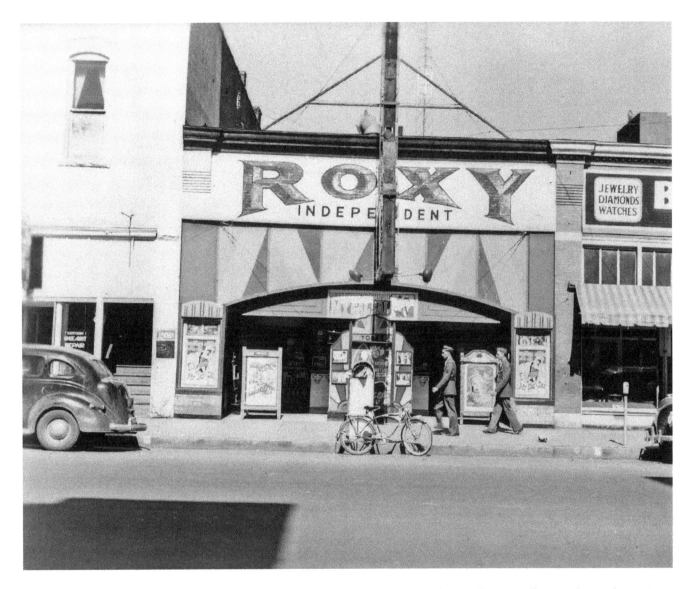

Soldiers stroll by the Roxy Theatre in Muskogee, 1942. Muskogee was the home of two military installations: the Muskogee Army Airfield, and the Army's Camp Gruber, which doubled as a prisoner-of-war camp.

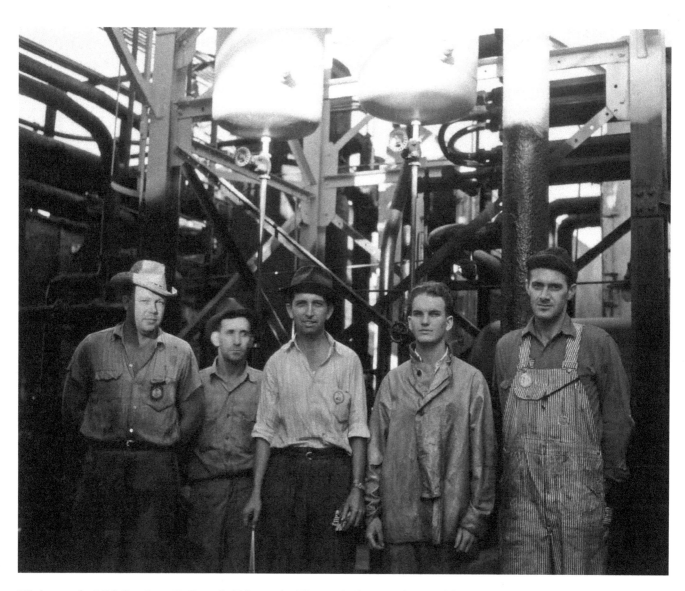

Workers at the Mid-Continent Refinery in Tulsa, 1943. The year before, employees of the refinery ended a lengthy and costly strike that inspired activist folksinger Sis Cunningham to pen a protest song with the lyrics: "All those anti-union ginks / Had better watch their step, by jinks / Or they too will hang from the derrick."

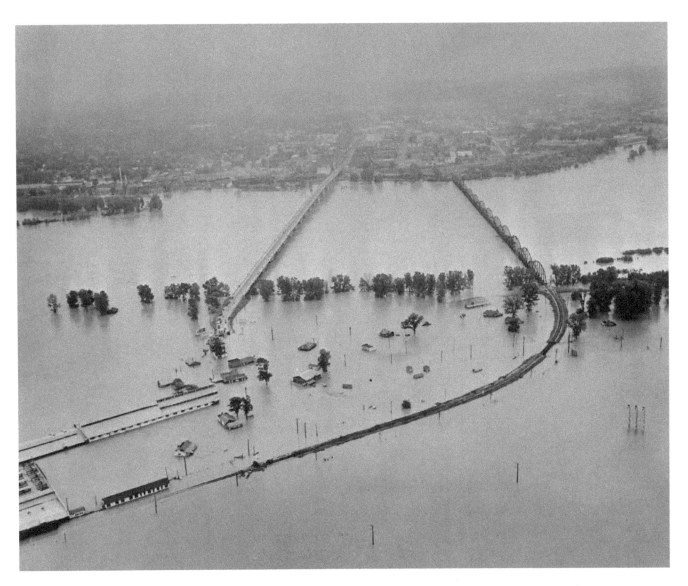

In May 1943 the Arkansas River rose to 110-year-high levels, flooding 600 city blocks of Fort Smith, Arkansas, seen at top, and obliterating nearly a third of the rich bottomlands of Oklahoma's Sequoyah County. Homes from the town of Moffett, Oklahoma, are shown floating away in the flood; those that weren't adrift were socked in with six feet of sand.

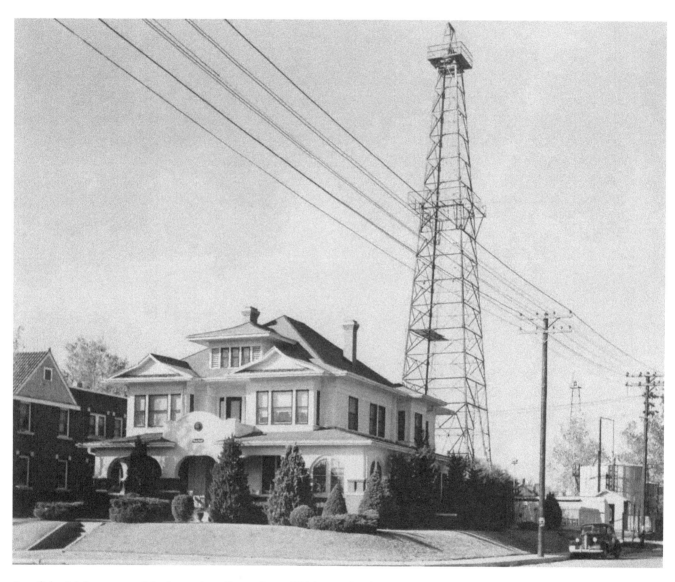

An oil derrick has sprouted in the garden of a northeast Oklahoma City home, 1944. Few yards in that quarter of the city—not even the State Capitol grounds—escaped the driller.

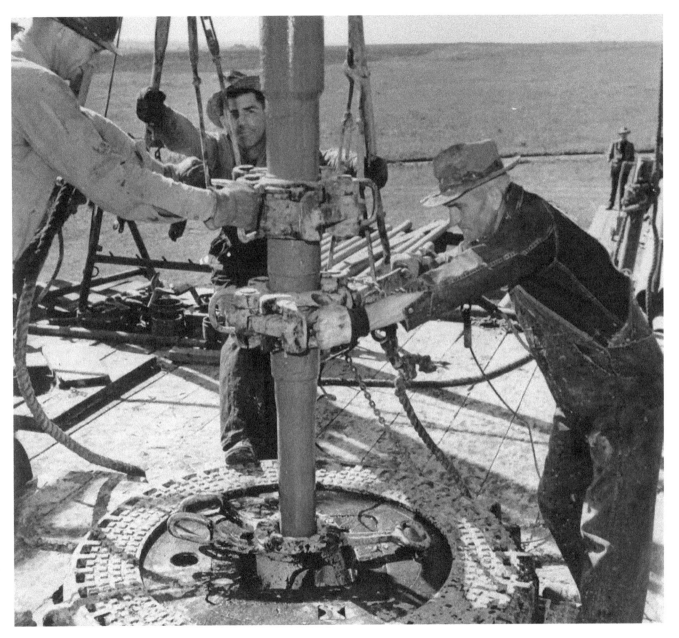

Wildcatters work to bring in a well, 1944. America's oil production was critical to fueling the thirsty war machines in the fight against fascism. Oil workers were reminded that one bombing run by a B-24 bomber used 1,800 gallons of fuel—enough to power the average American car for five years.

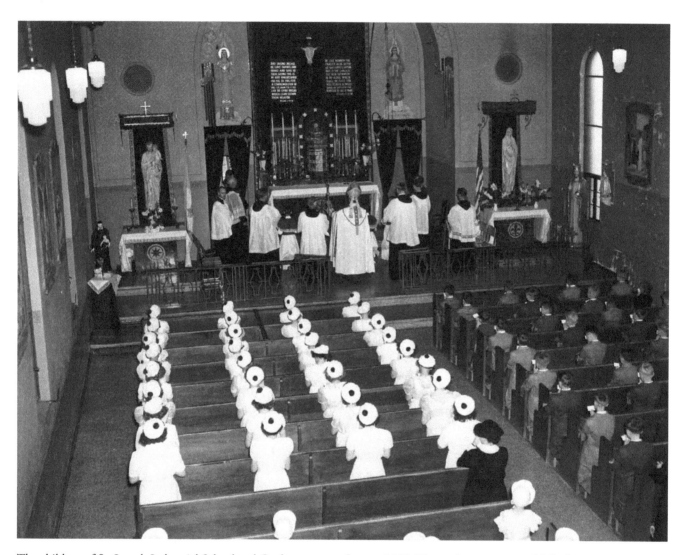

The children of St. Joseph Industrial School and Orphanage attend mass, 1946. The orphanage was established in 1911 west of the new town of Bethany and would eventually include a home for unwed mothers and a seminary.

I'VE NEVER BEEN TO HEAVEN, BUT I'VE BEEN TO OKLAHOMA

(1946–1950s)

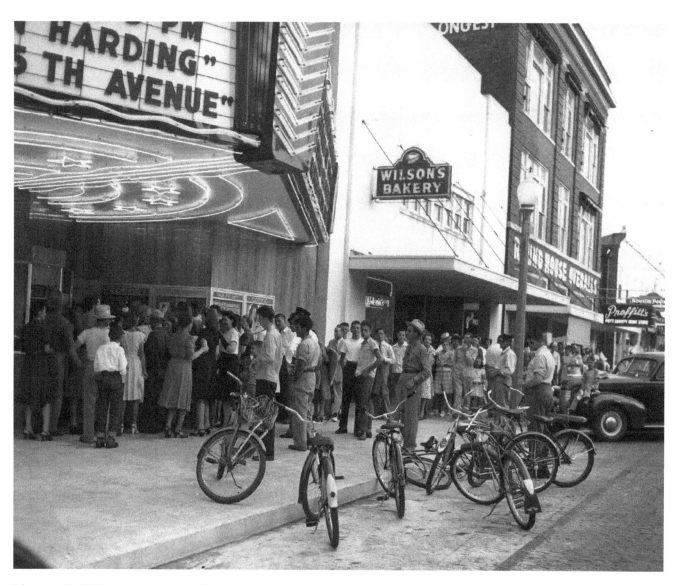

The Hornbeck Theatre in downtown Shawnee, July 1947. After Shawnee won the Pottawatomie County seat from Tecumseh in 1930, economic diversity and a central location helped it remain a viable city.

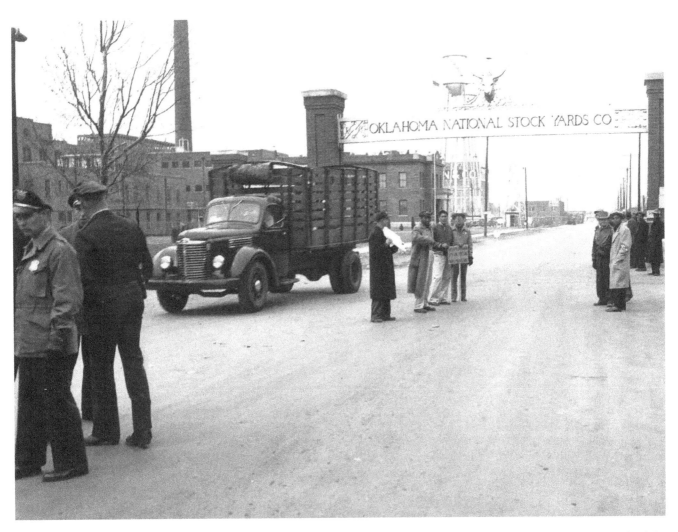

Pickets mill around near the entrance to the Oklahoma National Stock Yards in Oklahoma City, 1948. Throughout much of the spring that year, meatpackers in the city took part in a nationwide strike by the national union. Workers met violence and death in other cities, but the strike was largely peaceful in Oklahoma City.

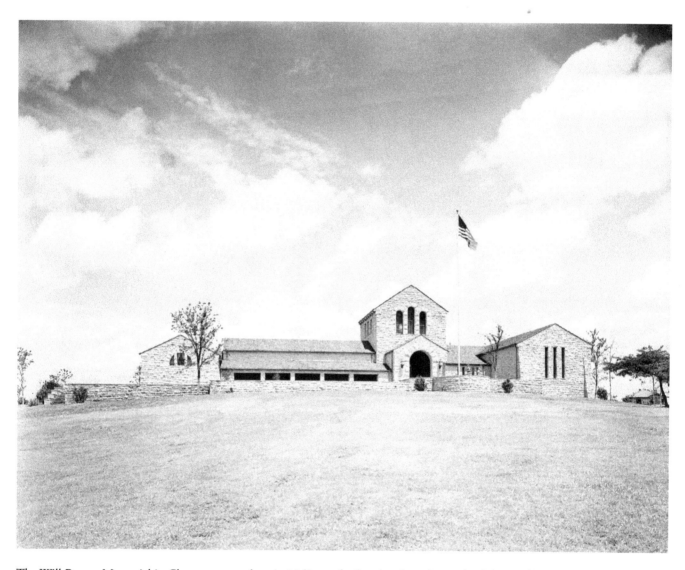

The Will Rogers Memorial in Claremore, seen here in 1948, was built a decade earlier on land donated by the Rogers family. Even though Rogers once said memorials ought to be living buildings and not monumental heaps of stone, the chairman of the memorial declared the place "simple and homespun. Will would have liked it."

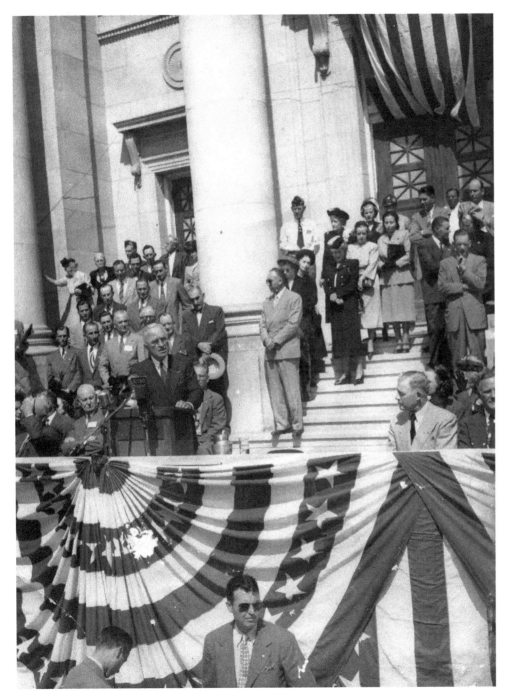

President Harry S. Truman made one of his famous whistle-stop tours through Oklahoma during his 1948 reelection campaign. At Ardmore he left the train to address the crowd on the steps of the First Methodist Church. Although the population of Ardmore was only 20,000, police estimated 40,000 people were in attendance.

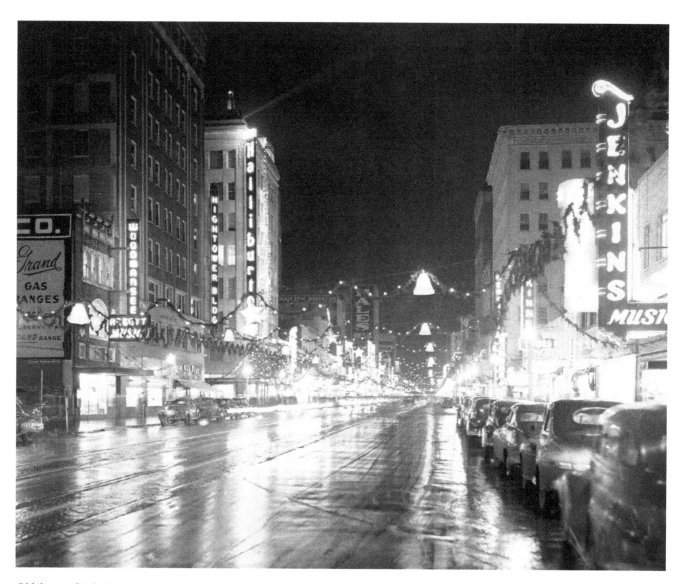

Oklahoma City's Main Street was aglow with new Christmas decorations in this view east from Walker Avenue in 1949.

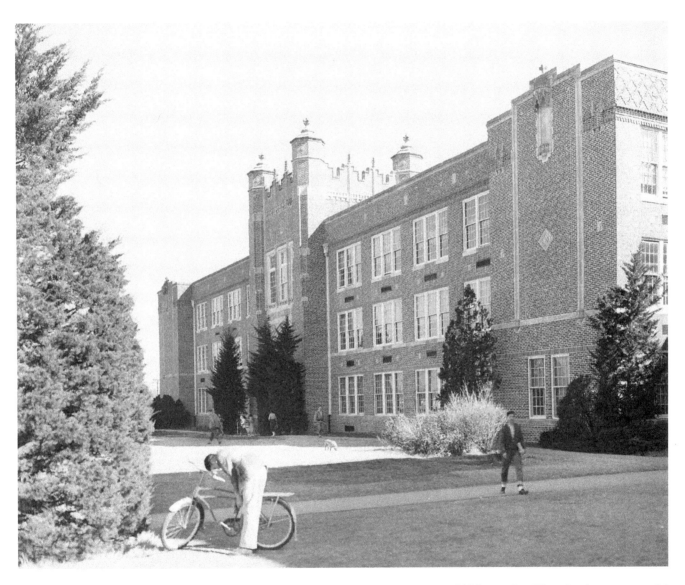

Capitol Hill High School was established in 1928 during a major building program in Oklahoma City. The school was a perennial powerhouse in football in the 1950s and was reigning state champion when this photo was snapped in the spring of 1950.

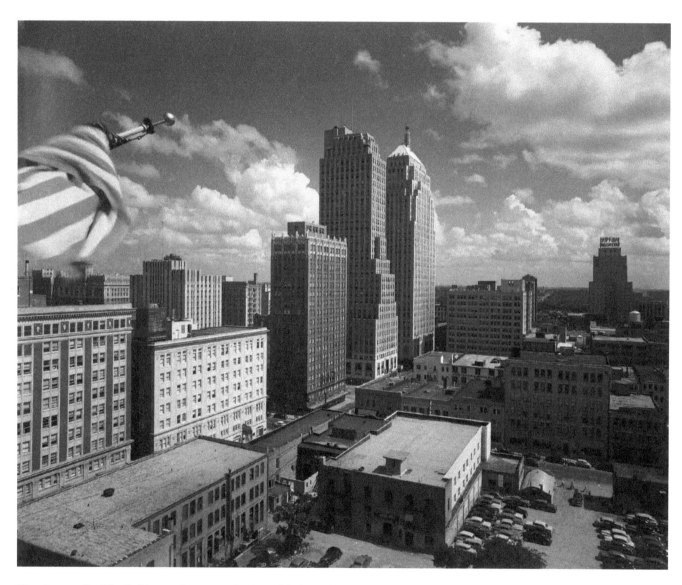

The sheer wall of the Robinson Canyon is clearly visible from this vantage point atop the Federal Building in Oklahoma City, 1950. From left to right, the tall buildings are the Braniff, Kerr-McGee, Petroleum, Ramsey Tower, and First National Bank.

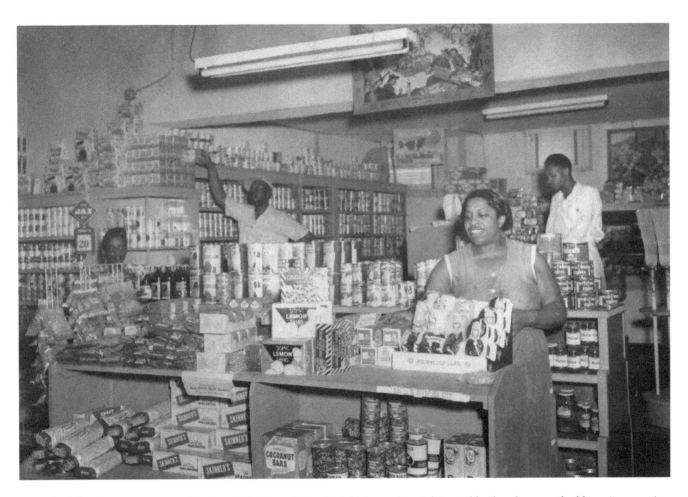

Inside Wilson's grocery store at Northeast Eighth and Kate in Oklahoma City. This neighborhood grocery had been in operation for several years when Andrew Wilson took it over around 1949. He ran it throughout the 1950s.

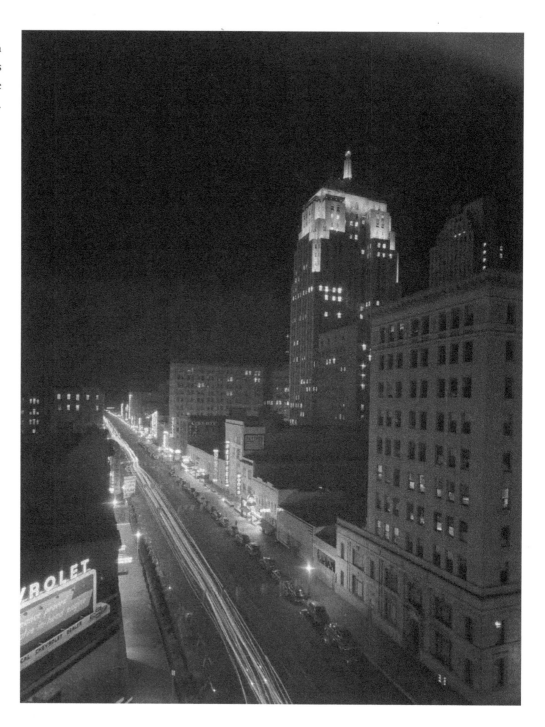

Oklahoma City's Main Street is aglow in this night view taken from the Huckins Hotel, 1951.

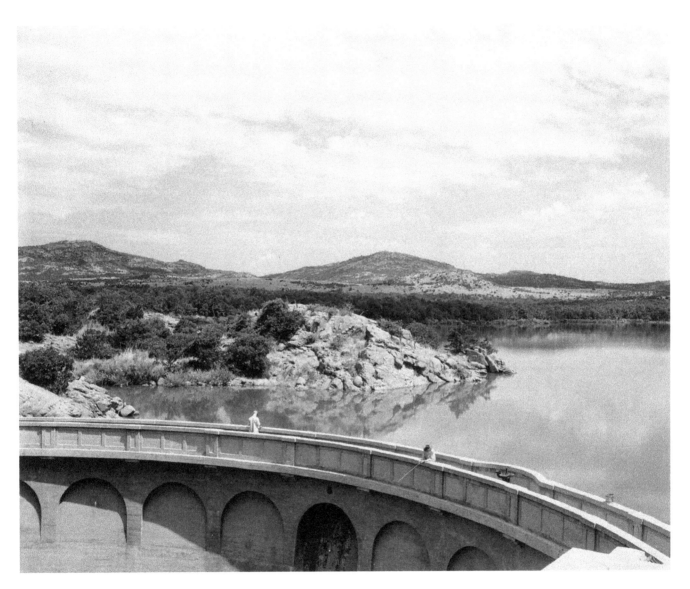

A miniature replica of the Hoover Dam, the Quanah Parker Lake Dam, seen in 1951, creates a body of water that stands in defiance of the arid Wichita Mountains all around it. Oklahoma was a willing recipient of numerous federal reclamation and soil conservation programs from the 1930s to the 1960s.

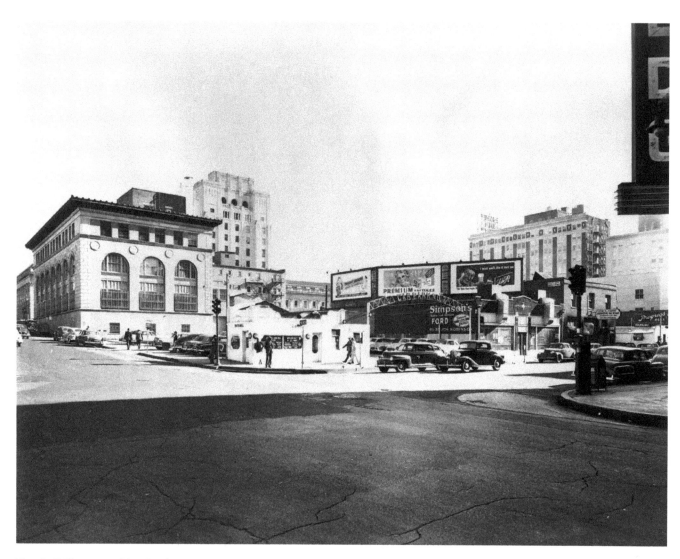

Tony's Grill, operated by Greek immigrant Tony Kiriopoulos, clings to the corner of Northwest Second and Harvey in Oklahoma City, 1952. By year's end the corner building would be razed and a five-decker parking structure erected on the site.

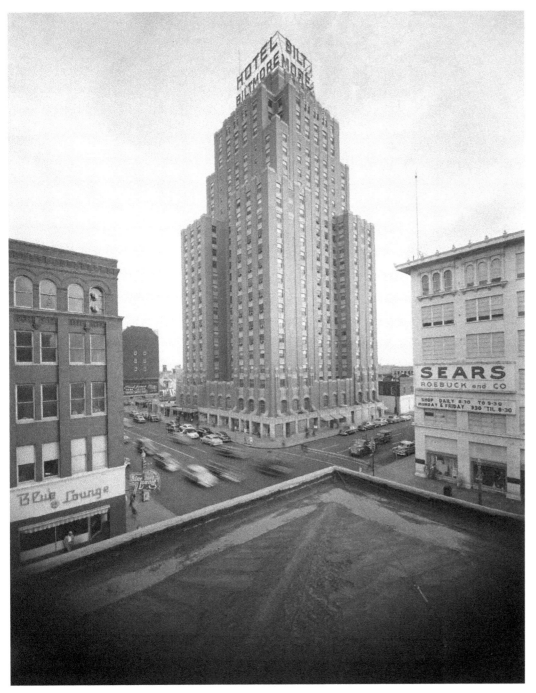

Called "a city unto itself," the Biltmore Hotel was the largest hotel in the state when it was constructed in 1932. Here the Biltmore is seen on its twentieth anniversary.

Notes on the Photographs

These notes, listed by page number, attempt to include all aspects known of the photographs. Each of the photographs is identified by the page number, a title or description, photographer and collection, archive, and call or box number when applicable. Although every attempt was made to collect all data, in some cases complete data may have been unavailable due to the age and condition of some of the photographs and records.

CPSIA information can be obtained
at www.ICGtesting.com
Printed in the USA
JSHW071650100423
40145JS00014B/840